Acknowledgements:
This book is dedicated to the memory of Diana, Princess of Wales.
Your inspiration and legacy lives on ...
And
To the memory of my beloved grandfather Mehmet Ismail.
Your example of decency will stay with me always.
Love you.

Thank you to all my family and friends for your support.
Special thanks to Roger G. Taylor and Peter Taylor for all your help.

I'd like to sincerely thank each and every artist who features in this book. It has been an honour and pleasure working with you all.

Images:
Page 33 – Princess Diana, 1982 ©Licensed by the Andy Warhol Foundation for the Visual Arts, Inc/ARS, New York
and DACS London 2007. Caxton Publishing has paid DACS' visual creators for the use of their artistic works.
Image supplied by SCALA Florence.

p. 67 – HRH Princess of Wales (1961-97), 1986 (oil on canvas) by Foster, Richard (b.1945) ©Private Collection/ The Bridgeman Art Library
p. 81 – Diana Princess of Wales (acrylic on canvas), 1981 by Bryan Organ. Courtesy of the National Portrait Gallery, London, UK
p. 102 – Votive Offering, 1987 (oil on canvas) by Durand (Contemporary Artist) ©www.durand-gallery.com/ The Bridgeman Art Library
p. 122 – Untitled, 1999 (oil and collage on canvas) by Keane, John (b.1954) ©Private Collection/ © Angela Flowers Gallery, London, UK/
The Bridgeman Art Library
p. 131 – HRH The Princess of Wales (1961-97) (oil on canvas) by Zohar, Israel (b.1945) ©Private Collection/ Roy Miles Fine Paintings/
The Bridgeman Art Library
p. 164 – Diana, 1997 (oil on canvas) by Durand (Contemporary Artist) ©www.durand-gallery.com/ The Bridgeman Art Library

Published in 2007 by Pop Art Books
20 Bloomsbury Street, London WC1B 3JH

Designed and produced for Pop Art Books by
Open Door Limited, Uppingham, Rutland

Editor: Robert Matthews

Title: Diana in Art
ISBN: 978 1 904957-03-4

Diana
in art

compiled by
Mem Mehmet

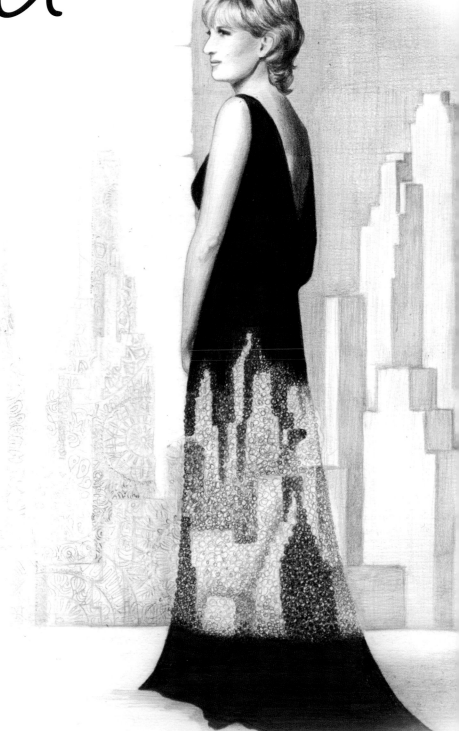

Pop Art BOOKS

20 Bloomsbury Street
London
WC1B 3JH

INTRODUCTION

THE WALLS OF THE GREAT ART GALLERIES OF EUROPE are lined with dominating portraits of princesses and princes, queens and kings. They gaze out and down at us, visions of privilege and status, possessed of wealth and power, and another less tangible attribute – separateness. In the main, these portraits which now hang before us were not meant for our eyes – they were commissioned from elite painters by their elite patrons, for the private pleasure that they would bring within their closed palaces and fine houses. This book, containing contemporary artworks brought together for the first time, constitutes an altogether different type of gallery from the traditionally exclusive setting of our royal ancestors' portraits – a collection of open, unrestricted, expressive art, reflecting the image of an utterly modern princess.

Millions of people throughout the world felt warmth towards Diana, Princess of Wales, a feeling which few other members of royal families have inspired – it came from a sense that, behind the grandeur of her position, she was essentially a good person. And among those millions were many who felt impelled at the time of her death, and in the years since, to bring her into their art. As the paintings and drawings in this volume show, they have chosen to do this in a remarkable variety of ways – sometimes literal, sometimes highly stylised, by turns romantic and realistic, but very frequently drawn from the immense catalogue of public photographs and film of Diana that flowed throughout the world during her brief reign as the epitome of celebrity.

The very existence of this extensive gallery perhaps reminds us of something else about Diana – that she was distant, yet ever familiar. Moving as she did in the most elevated echelons of international society, she is nevertheless associated with causes close to the common good. She embraced the sick and dying when there was no imperative for her to do so – she campaigned against manifest injustices in the world at large: so much so that vast numbers of people saw her as part of the fabric of a caring world and countless admirers expressed this by having her image on display in their homes. How far a step is it then, from this genuine regard, to a desire to capture her image in art? Many of the paintings and drawings in this book are done for their own sake – not as part of some larger project to promote a product or an event. They stand on their own merits. They tell us about the many different and sometimes unconventional ways in which the artists have assessed her significance and her meaning within the modern world in which she was so pervasive. Some of these will be seen to concentrate on the darker side of her experiences so widely exposed in

the tabloid press – others emphasise the outward glow of her beauty. Diana was accomplished but troubled, open but enigmatic – and all of this and more can be seen in the artworks collected between these covers.

The royal families of the past who appeared in those private collections were mostly known to a very limited circle – beyond their countries they were an indistinct presence, either a threat or, at best, a fair-weather ally, and, more than likely, an irrelevance to everyday life. This too is where Diana represents something special and unique – subjected as she was to an irrepressible media barrage, it should not surprise us that the art in this book comes from an extensive international community of artists. Diana was a presence in every country of the world – an unprecedented two thousand million people are estimated to have watched her funeral. Inevitably countless artists from around the globe have been inspired to invoke her image in their creative work.

The assessments of Diana that have continued to appear throughout the years since 1997 have been largely warm-hearted and sincere. Often they have been deeply touching, as in this early Internet posting to a British audience from an American correspondent: 'You may wonder why Americans seem so involved in your mourning for Princess Diana, and I think it surprises many of us also. However, the type of unconditional love she bestowed upon people extended beyond borderlines and reached us all … Through her powerful aura of kindness, she has gifted us all with a feeling of unity with people from countries all over the world, who share in your sense of loss, and miss her presence in the world. We grieve for her sons, her family, friends, and for each one of you; for the loss of your greatest national treasure, your English rose ….' It is my hope that the works brought together in this book will help, through the ever-evolving medium of art, to reassert the significance of Diana in the consciousness of both a nation and the wider international community. The power of her persona could never be contained by those portrait walls of the old galleries of Europe. Wherever you are reading this, her image and her memory are alive in the world.

Mem Mehmet

Watch Diana, she is only a little girl now but one day she will be a great beauty and a great star.

Earl Spencer
Father

I didn't realise when she was a child that she was going to turn out to be so beautiful. But all my friends were talking, male and female, saying she's going to be stunning. They could see it. But you don't notice it in your siblings.

Lady Sarah McCorquodale
Sister

SUSAN GOULET

Diana as a Young Girl

pastel on paper

20.5 x 25.5 cm

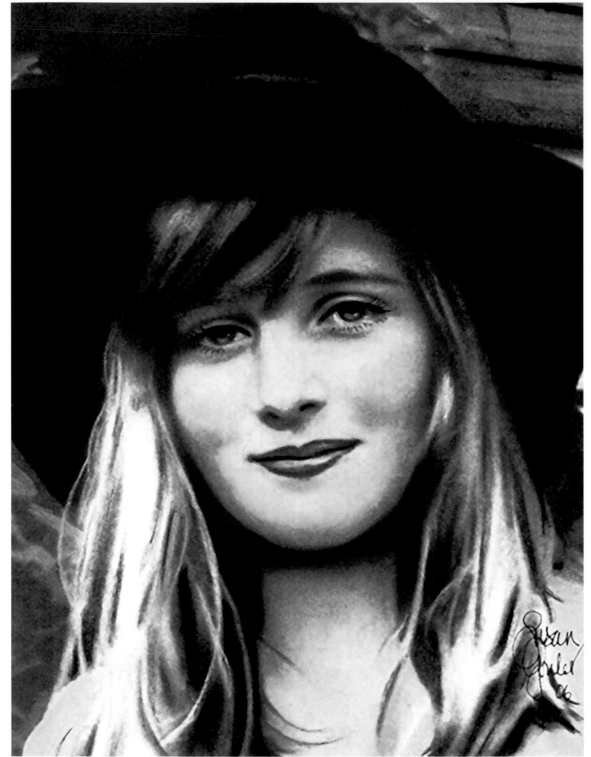

Everything in her tormented psyche turned on what had happened to her at the age of six, when her parents separated and left her to a loneliness that nothing could cure.

Clive James
Author and TV presenter

She was the sort of person who didn't like being out of a relationship. She didn't like being on her own because she needed constant reassurance that she was loved. That was her ultimate dream, to find the perfect husband, have more children and settle down. She was looking for the right man.

Carolan Brown
Friend

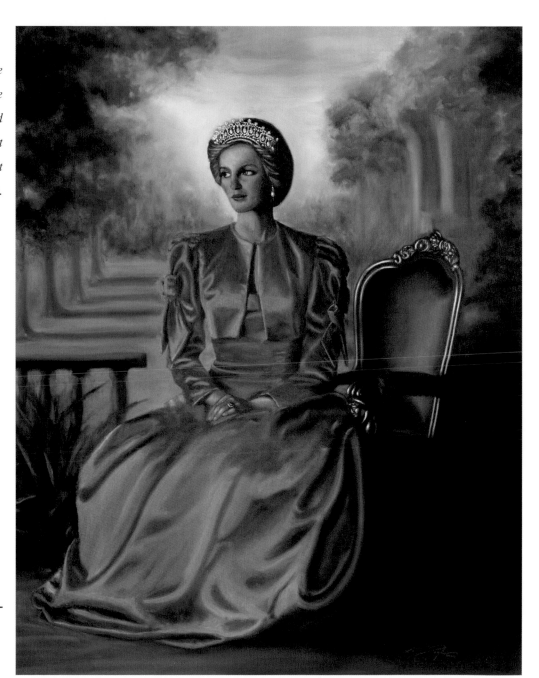

PATRICK TAYLOR

Princess Diana
oil on canvas
61 x 76 cm

The famous photograph from the Spencer family albums showing the teenage Diana sitting engrossed in one of Barbara Cartland's romance novels demonstrated how the young Diana was herself initially captivated by the idealised image of courtly love and romantic marriage. By the time of her separation, the spell had been savagely broken.

Andrew Morton
Author

She will reign forever as the Queen of Love.

Dame Barbara Cartland
Author and step-grandmother

She knew a lot about dance. She would have liked to be a dancer. She wasn't quite the right shape, but she could have made it into a ballet company more on the jazz side. She'd have made a very good jazz dancer.

Wayne Sleep
Professional dancer

SITI NURIATI HUSIN

Diana in the Garden (above)
coloured pencil on Stonehenge paper
56 x 76 cm

Dance with Me (right)
coloured pencil on paper
38 x 56 cm

She went to live at Buckingham Palace and then the tears started. This little thing got so thin. I was so worried about her. She wasn't happy, she was suddenly plunged into all this pressure and it was a nightmare for her. She was dizzy with it, bombarded from all sides. It was a whirlwind and she was ashen, she was grey.

Carolyn Bartholomew
Friend

STEPHEN PANNELL

Lady Diana Spencer, 1981

airbrush acrylic on canvas

10 x 10 cm

Once the engagement was announced, the focus of the press was even sharper on Lady Diana Spencer than it had been before. They were no longer speculating about who the Prince of Wales was going to marry, they were absolutely concentrating whole-heartedly, one hundred per cent, on the person he was going to marry.

Ronald Allison
Royal Press Officer

Marriage is a much more important business than falling in love. I think one must concentrate on marriage being essentially a question of mutual love and respect for each other. Essentially you must be good friends, and love, I'm sure, will grow out of that friendship. I have a particular responsibility to ensure that I make the right decision. The last thing I could possibly entertain is getting divorced.

Prince Charles

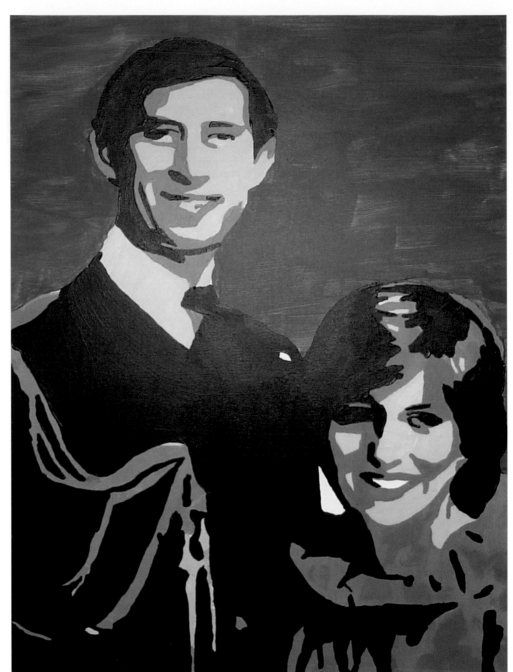

DANIEL BERG

Charles and Diana

acrylic on canvas

46 x 61 cm

I will always believe that the newspaper coverage that she received in the romance that went on with Charles, I am convinced helped the Prince decide to ask Diana to marry him. I think we were a big influence on it. So I would counsel Diana, who I thought and still do think, I think she's immensely tricky but I think she is delightful. Yes, I think anybody who meets her falls a little bit in love with her.

James Whitaker
Royal reporter

ORLENA ONSTOTT

Fairytale Romance

pastel chalk on paper

21.5 x 28 cm

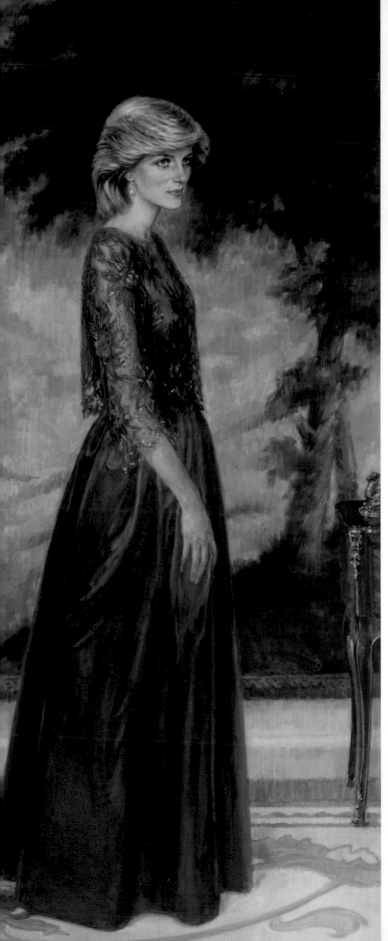

She was very sweet, very nice, and easy to get on with, not at all demanding, but quite shy. Fashion wasn't her thing at all; it was something that was really forced upon her, because she had to dress up for the part.

Elizabeth Emanuel
Designer

JUNE MENDOZA OBE

Early Days (for the Worship Company of Grocers)
oil on canvas
152.5 x 76 cm

During those years in the early eighties Diana was most admired for her fashion sense. Her wonderful wardrobe provided a terrific boost to the British fashion industry and millions of young women around the world began to 'Di' their hair.

HELLO!

DIEDRE BURKE

Royal Purple (opposite page)
oil on canvas
40.5 x 51 cm

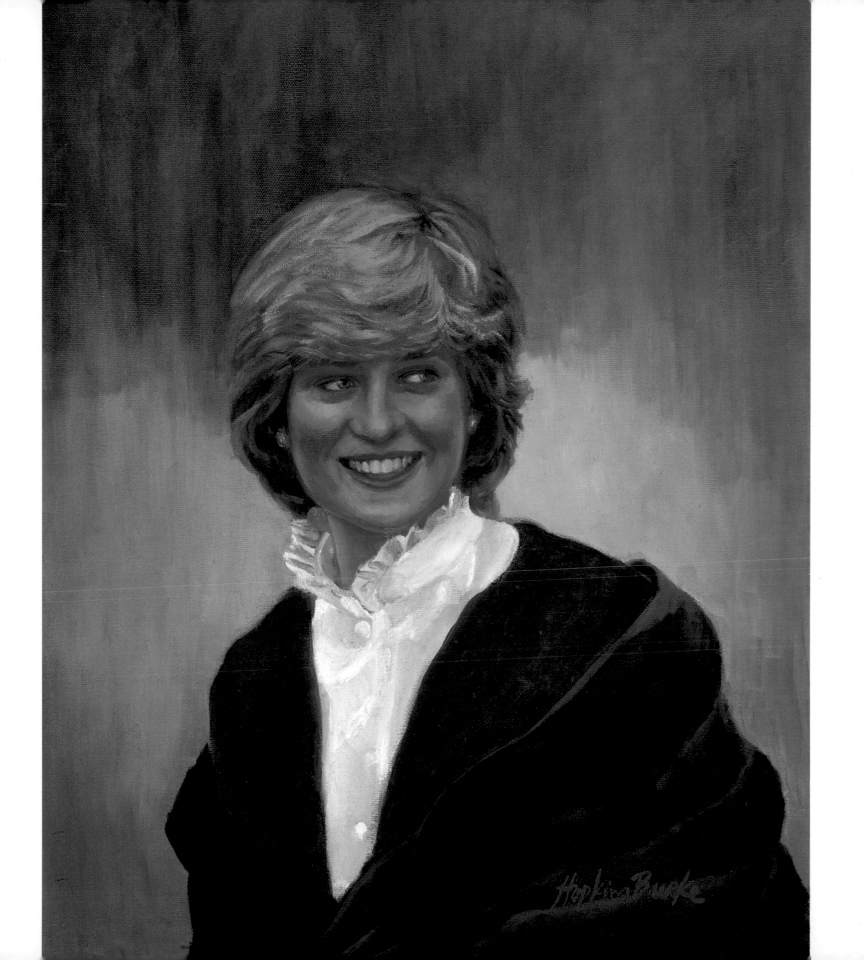

Fortunately for her the camera had already fallen in love with the new royal cover girl. However nervous she may have felt inside, her warm smile and unaffected manner were a photographer's delight. For once the camera did lie, not about the beauty she was becoming but in camouflaging the vulnerable personality behind her effortless capacity to dazzle.

Andrew Morton
Author

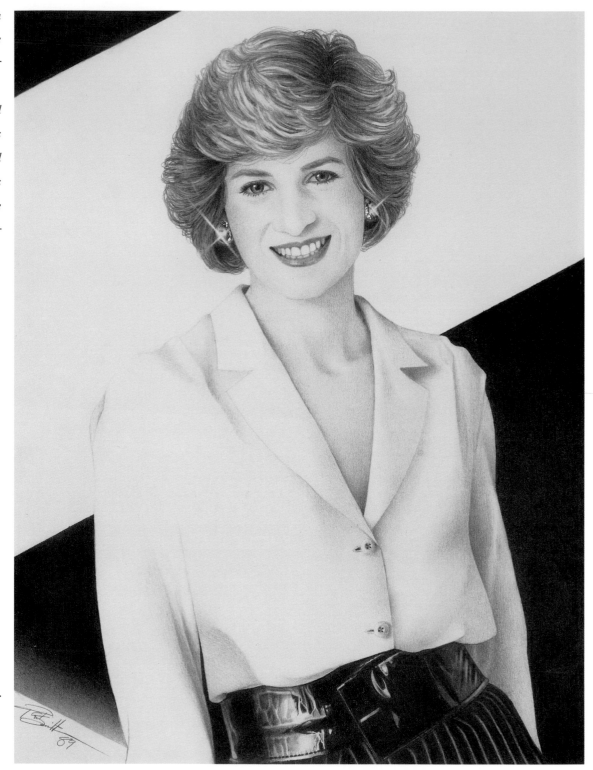

PHIL SMITH

Diana 1989

pencil on paper

21.5 x 28 cm

England and the world were warming to the young princess's innate poise and charm. People wanted her to be something very special, something in their own dreams. The princess wanted to reciprocate their love by wearing the right designs.

Catherine Walker
Designer

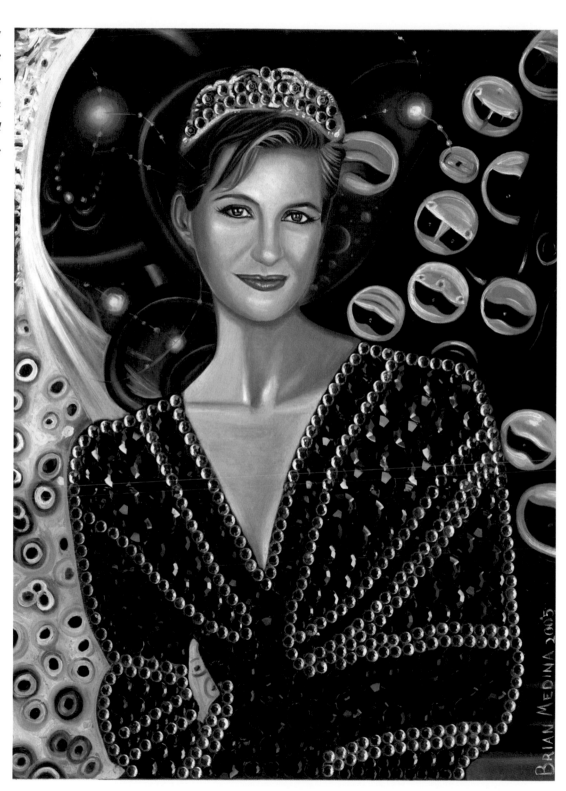

BRIAN MEDINA

In Memory of Princess Diana
oil and rhinestones on
illustration board
23 x 30.5 cm

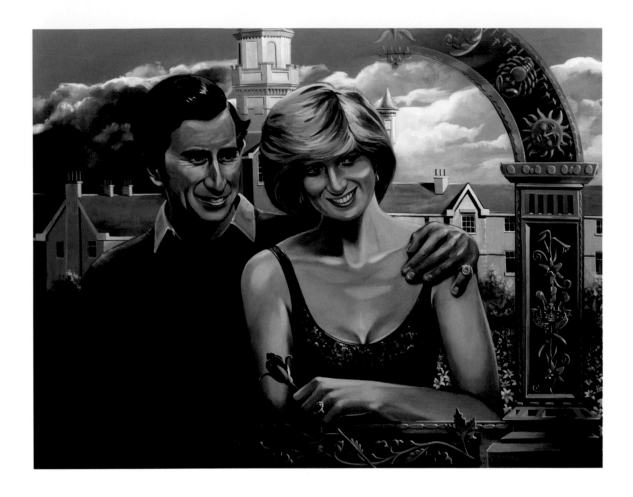

It did appear then how eminently suitable Diana was. She'd never had any serious affairs, she was nineteen and a half, extremely beautiful and most popular, and she seemed to share interests with the Prince of Wales. She gave the impression of loving the country life, in particular staying at Balmoral. She seemed to be madly in love with him and, after all, she did come from the stock of a family who had worked with and supported the Royal Family for many generations. And it seemed even more suitable because the Prince seemed like somebody who would want a younger girl to be his wife. She was young enough to be trained, and young enough to be helped, and young enough to be moulded.

Robert Spencer
Cousin

RICH THISTLE

Once Upon A Time
acrylic on board
96.5 x 73.5 cm

How could any man not be bewitched by the most famous princess in the world, perhaps the most beautiful in all history, who inspired no frightening awe or sense of remoteness, and could affect all the graces and wit of an ordinary human being in a manner the Windsors find so elusive?

Max Hastings
Evening Standard Editor

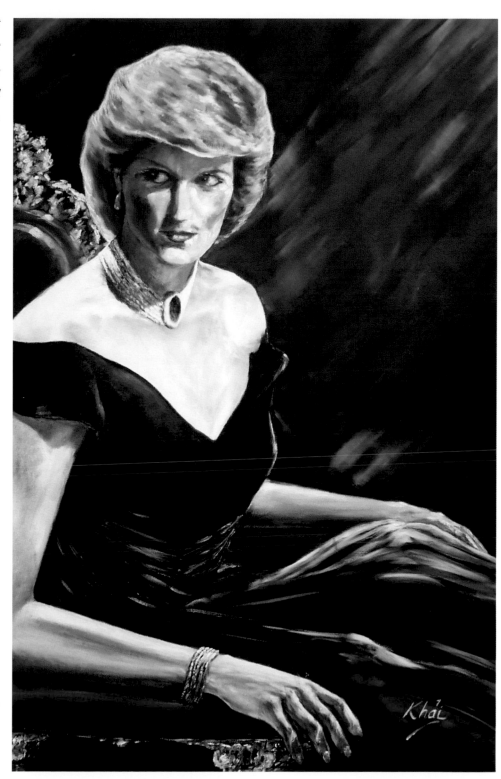

KHAI NGUYEN

The Princess

oil on canvas

76 x 101.5 cm

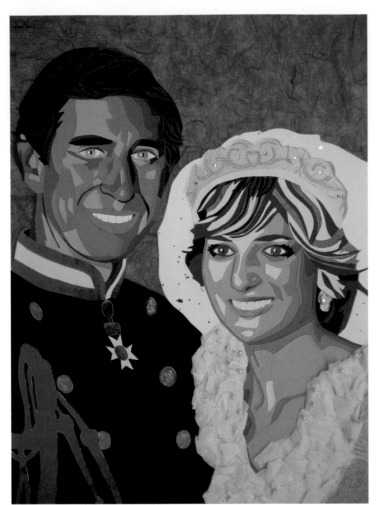

He was the most eligible bachelor in the world, the future King of England. She was, quite literally, the girl next door, a 20-year-old who had grown up on an estate in the shadow of the Royal Family's Sandringham retreat. When Prince Charles and Lady Diana Frances Spencer married on July

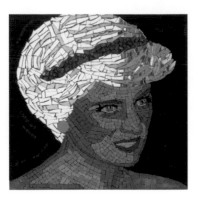

29th, 1981, three quarters of a billion people in 74 countries tuned in to a brilliantly choreographed spectacle, the Wedding of the Century.

Barbara Kantrowitz
Newsweek

CLAIRE MILNER

Charles and Diana (above left)

handmade paper, gold leaf, jewels and mixed media on board

37 x 44 cm

Diana Mosaic (above right)

gold leaf, mirror, glass and ceramic mosaic with fool's gold on wood

30 x 30 cm

Diana (right)

handmade paper and mixed media on board

22 x 30 cm

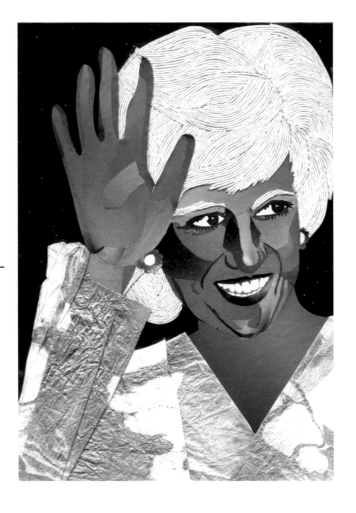

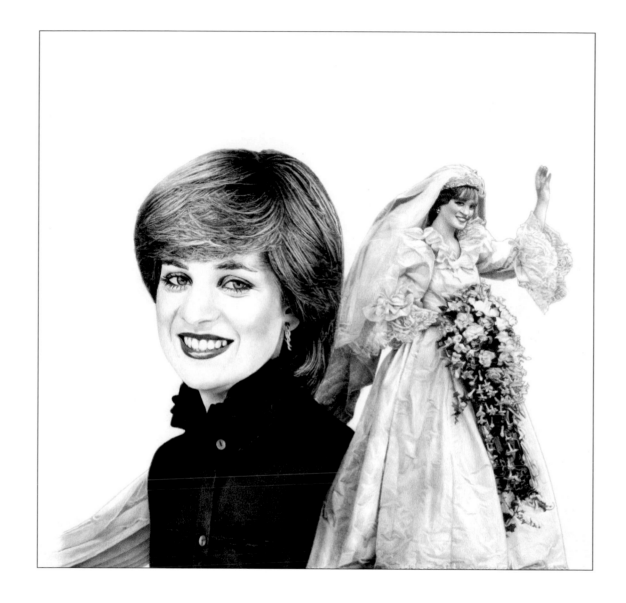

The nation rejoiced at the ceremony in St Paul's Cathedral and its joy over the marriage continued. For all her aristocratic breeding nothing could have prepared her for the burden of becoming a member of the Royal Family when she married Charles on July 29th, 1981.

The Sunday Times

WILLIAM DAVIES

Princess Diana, 2006

pencil (graphite) on paper

28 x 30 cm

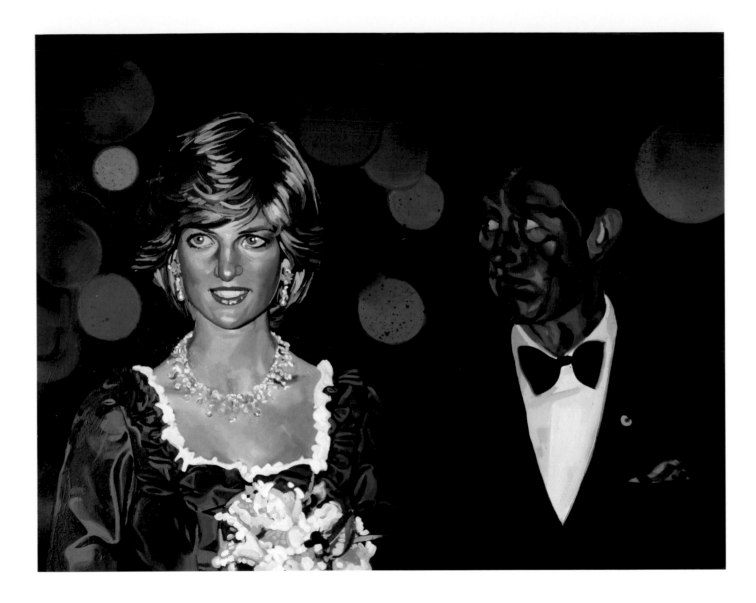

The fairytale continued at first, with Diana blossoming at her husband's side, and showing by look and gesture that she was happy and in love.

Judy Wade
Journalist

THOMAS GRIFFIN

Alone with Charles

oil on board

43 x 56 cm

We were told that it would be very bad of us if we all went to the Taj Mahal and nobody went with Prince Charles. I mean, what a stupid thing! ... When the Princess of Wales, the most photographable woman in the world, is sitting by the Taj Mahal for a photograph, who on earth is going to ever expect any photographers to go and photograph a man in a suit at a business forum?

Jayne Fincher
Photographer

TARREN MALHAM

Diana in Watercolour

watercolour on paper

40.5 x 30.5 cm

She had to really look at herself and where she was going. She only knew herself through her iconography, so she had to find out who the real Diana was.

Debbie Frank
Friend and astrologer

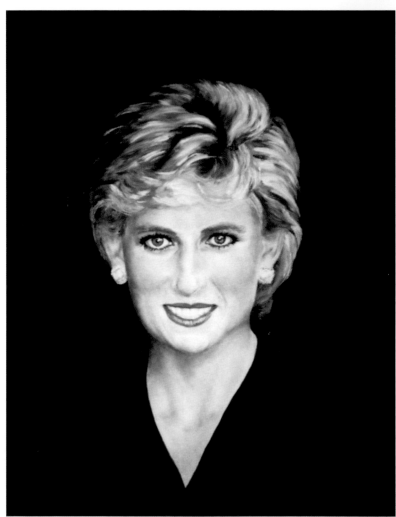

REISZ ILONA

Diana I *(above)*

Diana II *(below)*

both are oil on chipboard

both are 40 x 50 cm

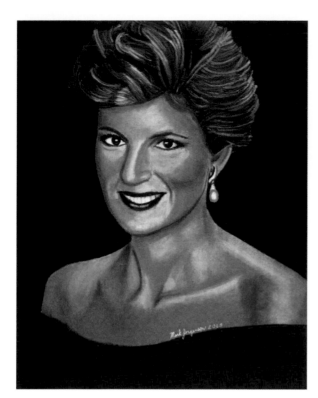

There was nothing like her and we were hungry – we, I'm talking about Britain ... she was a model girl but was far beyond that. Oh, we've got this supermodel representing Britain. Little did they know she was far bigger and greater than that. She had another agenda.

David Emanuel
Designer

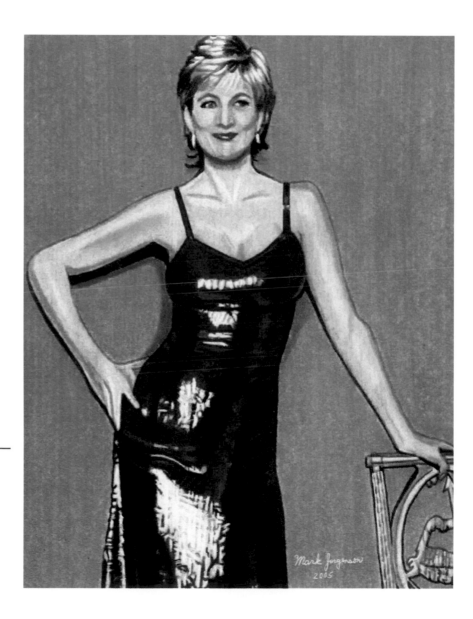

MARK JORGENSON

Princess Diana in Red *(above)*
coloured pencil
20.5 x 25.5 cm

Diana in Red Dress *(right)*
coloured pencils and watercolour
20.5 x 25.5 cm

When Lady Diana Spencer stepped out of her royal carriage, more than 800 million people around the world caught their breath as they glimpsed for the first time the bride in 'the dress' that had become the most closely guarded secret in fashion history.

NEWSNET5

The whole experience was such a life-changing event for us. All the windows had blinds down so nobody could look in. We used to leave false trails of thread outside, because there would be newspaper people going through all the rubbish bins, looking for scraps of fabric. They were speculating on TV what she was going to look like, and of course we knew, so it was great fun.

Elisabeth Emanuel
Dress designer

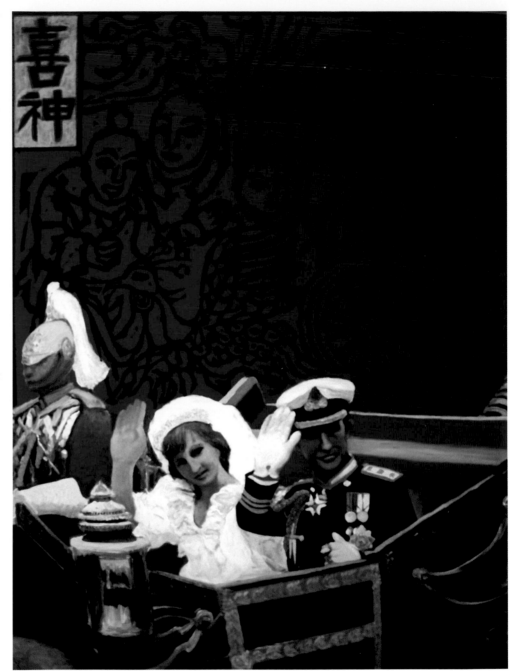

DR T. F. CHEN

Wedding Blessing
acrylic on canvas
122 x 91.5 cm

Diana had been the Cinderella of her family for long enough. She had felt her spirit suppressed by school routine and her character cramped by her minor position in the family. Diana was eager to spread her wings and start her own life in London. The thrill of independence beckoned.

Andrew Morton
Author

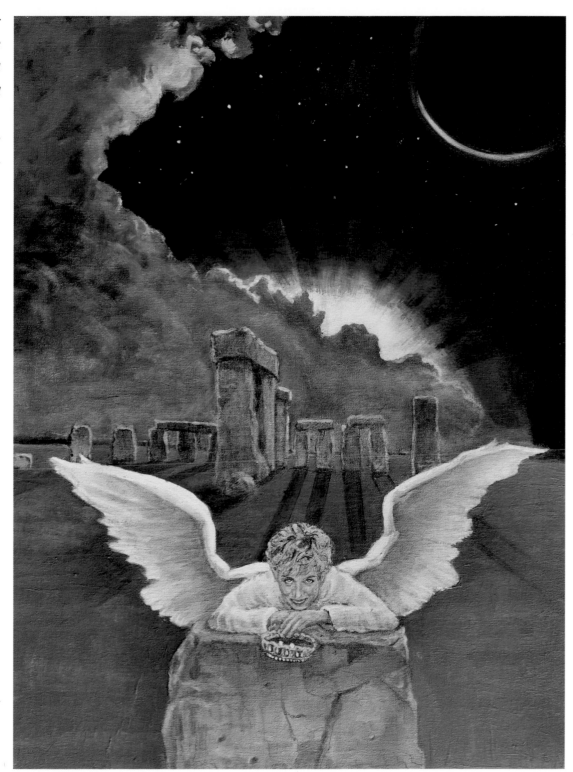

RON KEAS

Fantasy

oil on canvas

46 x 61 cm

She was a very touchy person and that became apparent very quickly because she was touching everybody. I think she quickly worked out that this is the best way to deal with it ... if you see the Queen doing a walkabout it's very dignified and quite formal. She'll walk down the edge of a barrier and she'll take some flowers very gently and elegantly, and maybe occasionally she might shake a hand. But they normally don't shake hands. And normally the royal ladies would always have these long white gloves on. Diana didn't wear gloves. It was completely different.

Jayne Fincher
Photographer

KRISTEN WOOLF

Diana in Profile

oil on masonite

30.5 x 40.5 cm

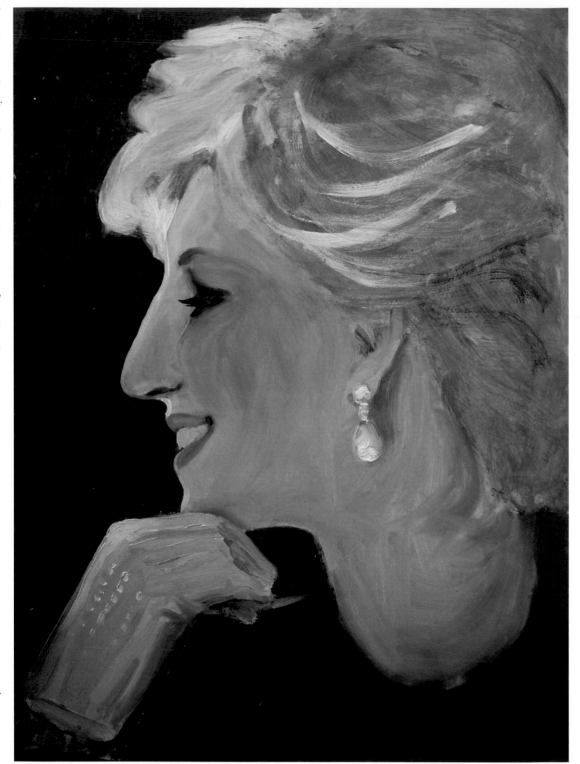

It was amazing to stand back away from her and just watch the reaction. 'Fairy dust' I called it. She used to sprinkle her fairy dust around and give joy to people, however they were or whatever their situation was.

Susie Kassem
Friend

BOREA DOMENICO

She Sparkles

graphics

20.5 x 25.5 cm

I will fight for my children on any level so they can reach their potential as human beings and in their public duties.

Diana

I think she hadn't thought beyond having children and producing heirs, initially. She had something that she couldn't really define, but it challenged the authorities, and challenged the established way of doing things in this country. She wanted to show that a royal family can play a participatory role in a democracy, can participate with the people.

Felix Lyle
Astrologer

IVAN VALTCHEV

**Princess Diana with
Prince William**

oil on canvas

36 x 46 cm

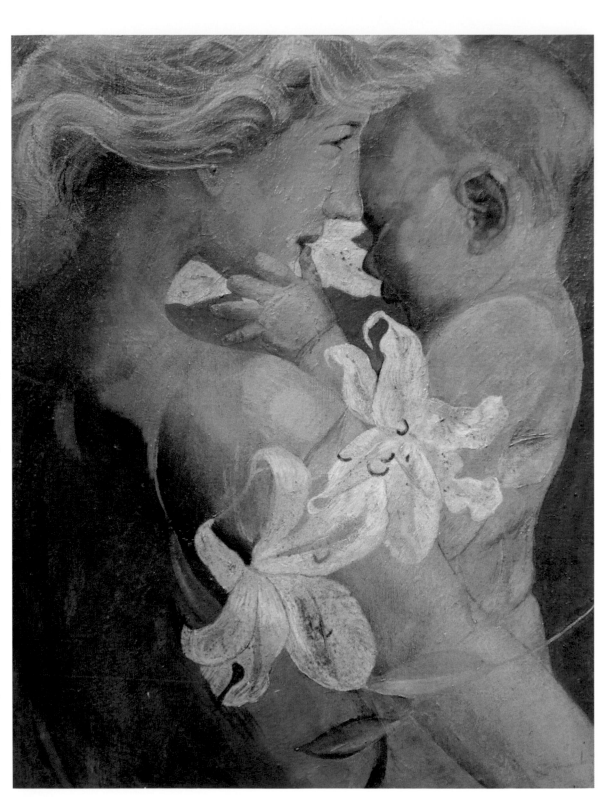

The time I remember her best was the big ball at Belvoir Castle. Quite lovely. She looked magnificent whenever I saw her that summer in fact, and she seemed to have a great number of admirers. I remember even some of the young men who were staying with me who knew Diana remarking on how absolutely lovely she looked. Prince Andrew was at the dance and he danced with Diana a lot.

Robert Spencer
Cousin

I felt like she was a little girl caught up in this whirlwind. She was smitten with me since I was so tall. I was smitten with her since she was so tall. But she was married and so was I. I probably would have gone after her if circumstances had been different.

David Hasselhoff
Actor

ROBERT MCGINNIS

Queen of Hearts
oil on board
44.5 x 71 cm

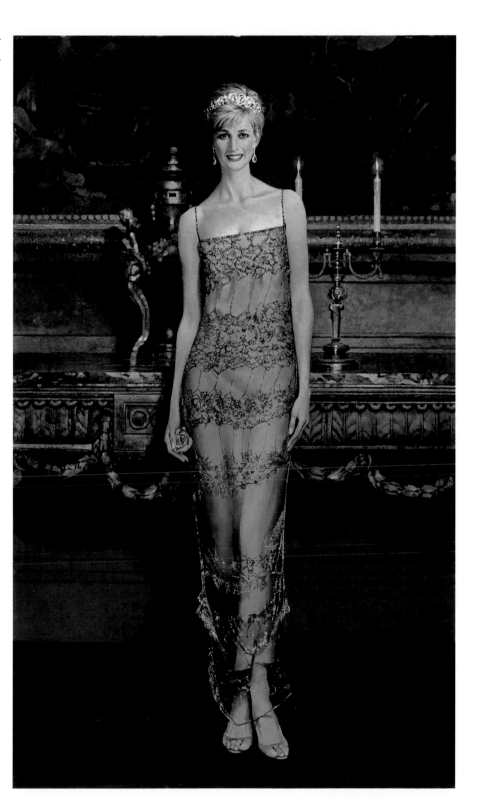

Someone said to me that the two most famous people in the world are the Pope and my daughter. I am so proud.

Earl John Spencer
Father

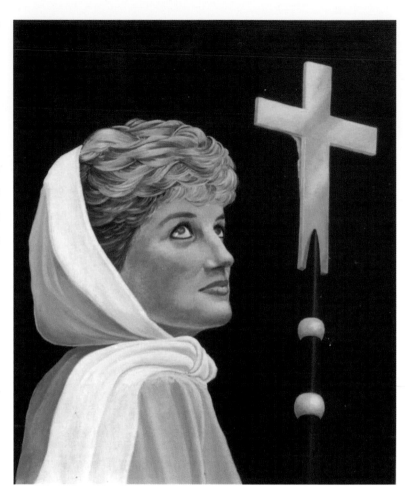

She strikes me as an immensely Christian figure and she has the strength which I think true Christians have and the direction in her life which others can envy, that sureness of her purpose and the strength of character and position to do an enormous amount of good. I am sure she will continue to do so.

Earl Charles Spencer
Brother

MALCOLM PERRY

> ***A New Direction***
> *oil on canvas*
> *51 x 61 cm*

She was Cinderella, the beautiful maiden who captured the heart of the handsome and beloved Prince, and if the facts didn't match that, we overlooked the facts. It was the story that was important, and even more than that, the pictures.

Leah Garchik
San Francisco Chronicle

MICHAEL BURKE

> ***Di Church*** *(opposite)*
> *oil on canvas*
> *40.5 x 51 cm*

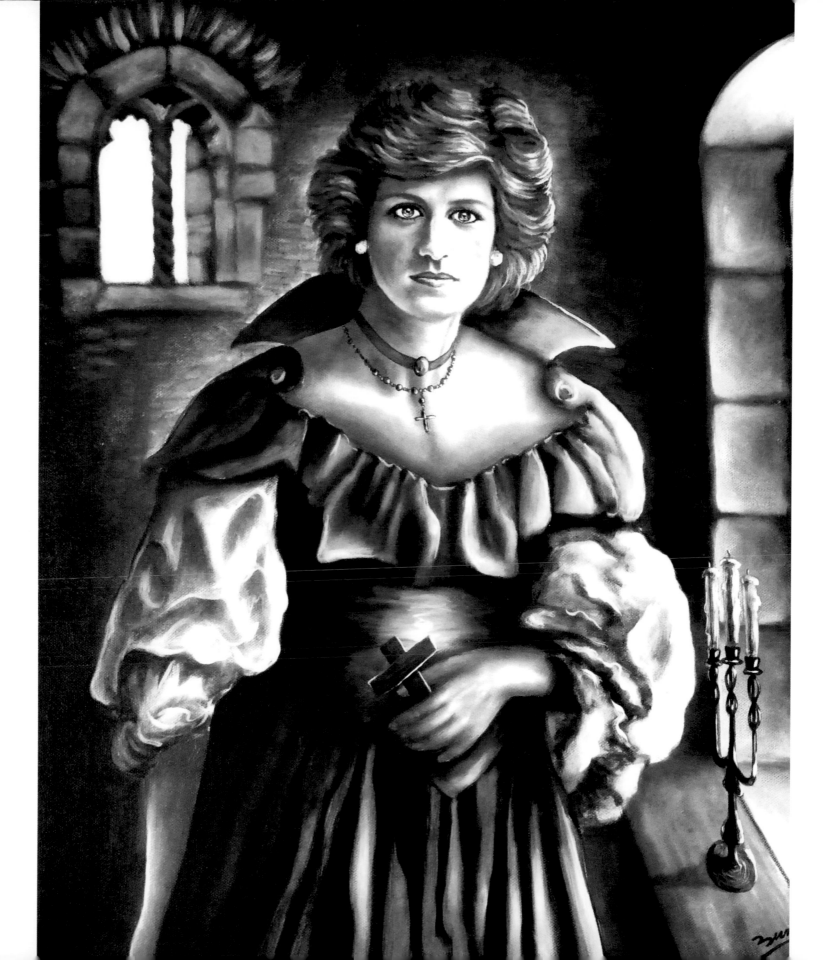

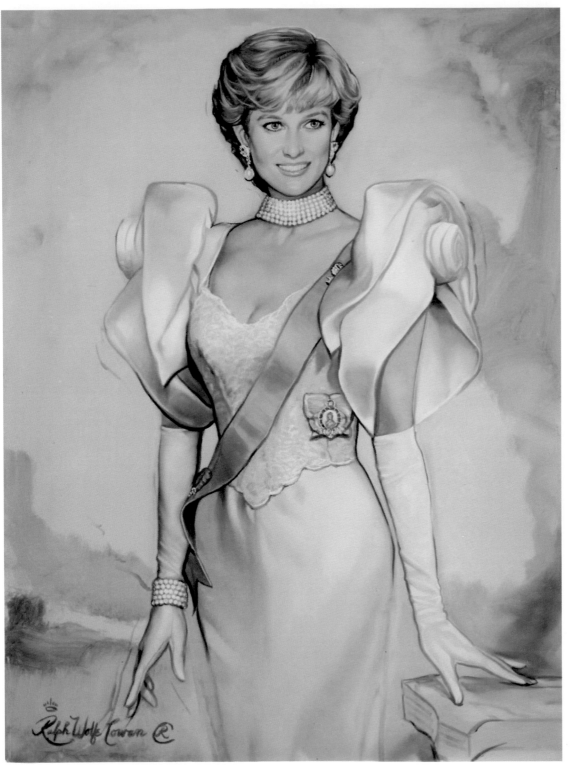

It was the women's pages that really went to town on Diana. I was writing endless features about the wonderful ruffled romantic clothes she wore. I wrote reams and reams about her wardrobe, her weight-watching, her diet secrets. The Palace thought that we were trivialising the monarchy by writing all this tosh about Diana's frocks, her hair do.

Judy Wade
Journalist

RALPH COWAN

Queen of Hearts
oil on board
76 x 102 cm

ANDY WARHOL

Princess Diana, 1982 *(opposite)*
© Photo SCALA, Florence
The Andy Warhol
Foundation Inc.
©Licensed by the Andy Warhol
Foundation for the Visual Arts,
Inc/ARS, New York and DACS
London 2007

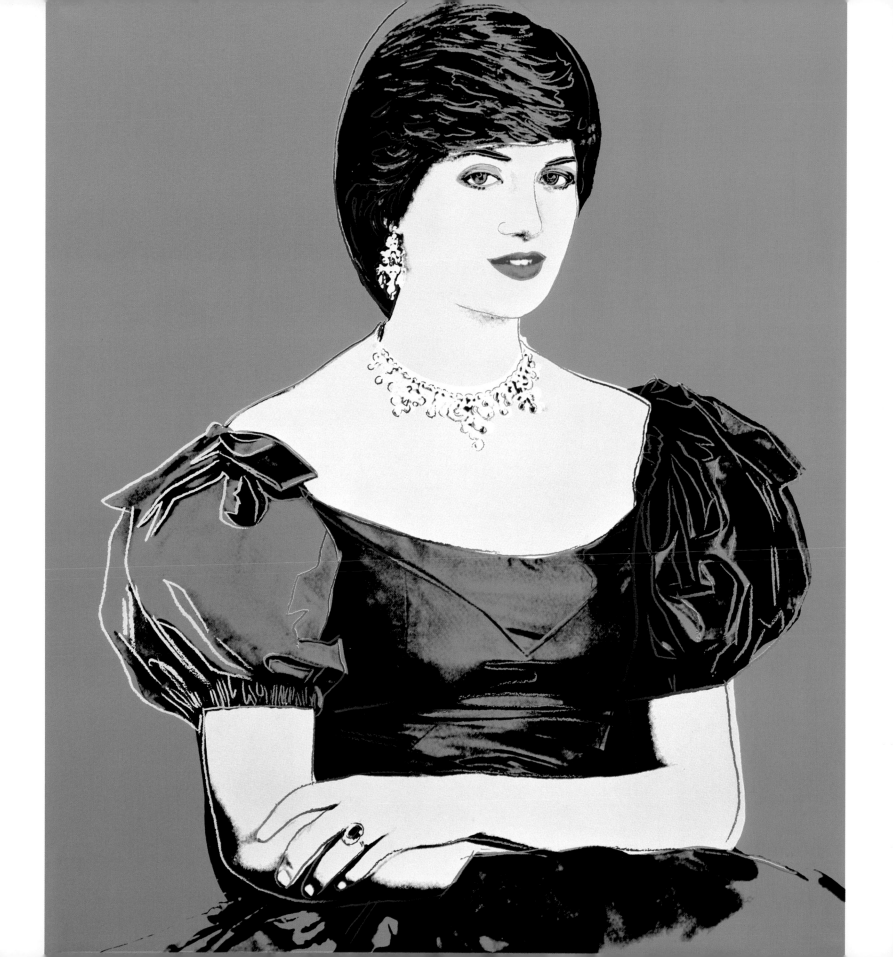

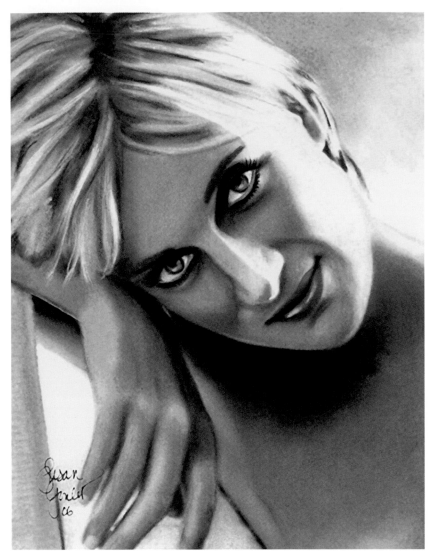

She was very good in front of the camera, very natural, but at the same time you had to talk to her or she could freeze very easily. The best thing was to take her off her guard. That's why the paparazzi pictures are all so fantastic. I had to recreate that, to make her relaxed, happy, laughing. When I looked at the photos afterward I knew I had shot well.

Patrick Demarchelier
Photographer

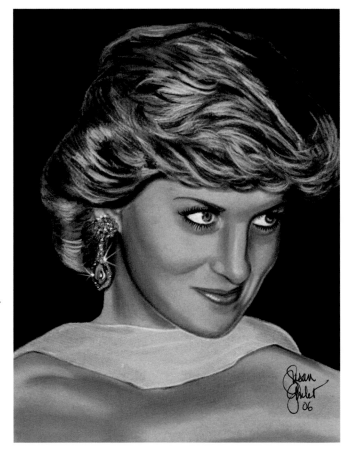

SUSAN GOULET

Happy at Last (above)

pastel on paper

20 x 25.5 cm

Dazzling Di (right)

pastel on paper

20 x 25.5 cm

She was very easy to photograph. You had to be a pretty useless photographer if you didn't get a good picture of her.

Tim Graham
Royal photographer

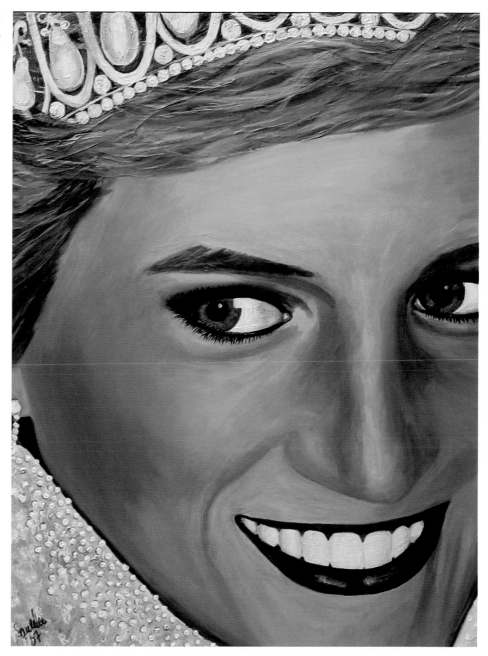

MARK JANICELLO

One More Please, Diana

acrylic on linen

60 x 80 cm

It happened before our very eyes, the transformation from this shy teenager, who hid beneath big hats, and hung her head, into the self-assured woman and mother, confident in her beauty. It never struck me that she was conceited about this, I think she just enjoyed being who she was, and I'm sure, too, grateful for being as beautiful as she was.

Jayne Fincher
Photographer

JOANNE ARMITAGE

Faces of Diana
digital painting
46 x 30.5 cm

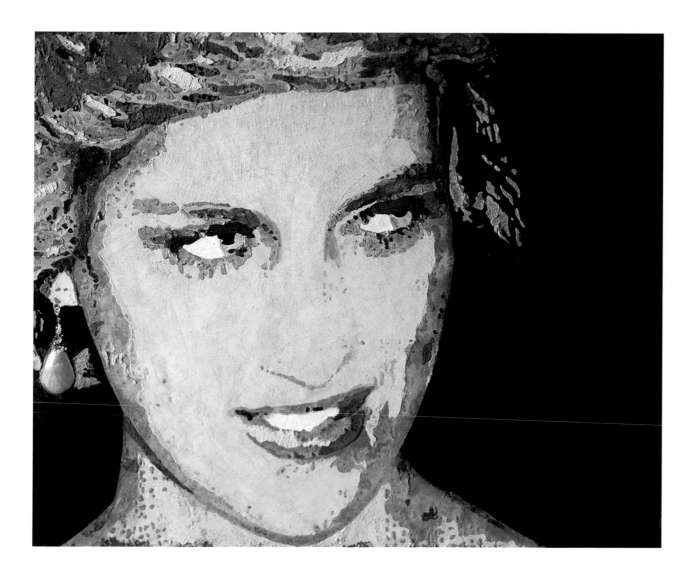

A luminous personality. She is here as a member of the Royal Family, but we are honouring the Princess in her own right, who aligned herself with the ill, the suffering and the downtrodden.

Henry Kissinger
Veteran diplomat

FABRIZIO RUGGIERO

Fresco Portrait of Princess Diana

fresco with sand, plaster and cocciopesto on a mounted board

130 x 100 cm

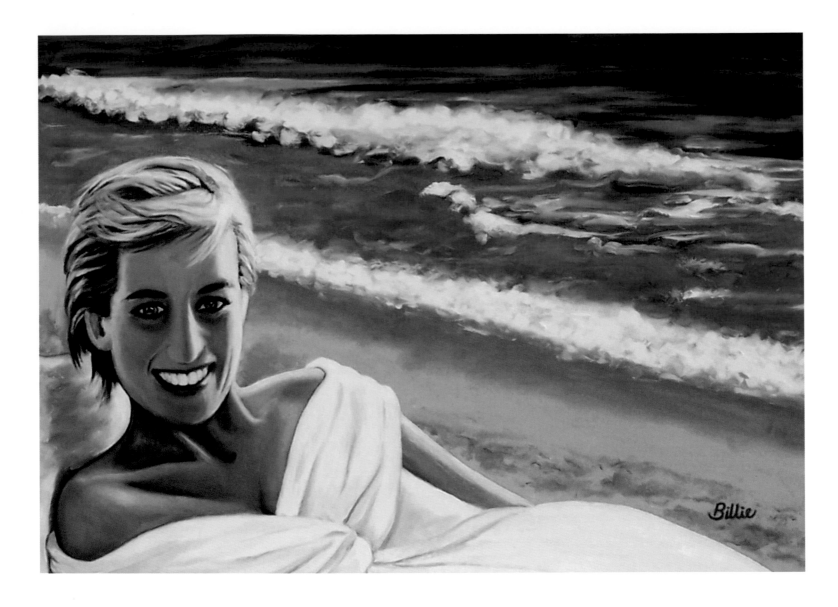

I look forward to the day when I can run along a beach without a policeman following me.

Diana

BILLIE MANN

Princess Diana

oil on canvas

46 x 61 cm

The headlines in Britain confirmed that the Princess was an ace card on the diplomatic front. Whatever her personal battles at the time, she was becoming virtually infallible as the roving ambassador she had always intended to be. No amount of whispering campaigns from the men in grey suits could dislodge her confidence – or the global esteem in which she was held.

Paul Burrell
Butler and friend

BRIAN PARTRIDGE

Queen of Hearts 3
pen, ink and watercolour
15 x 23 cm

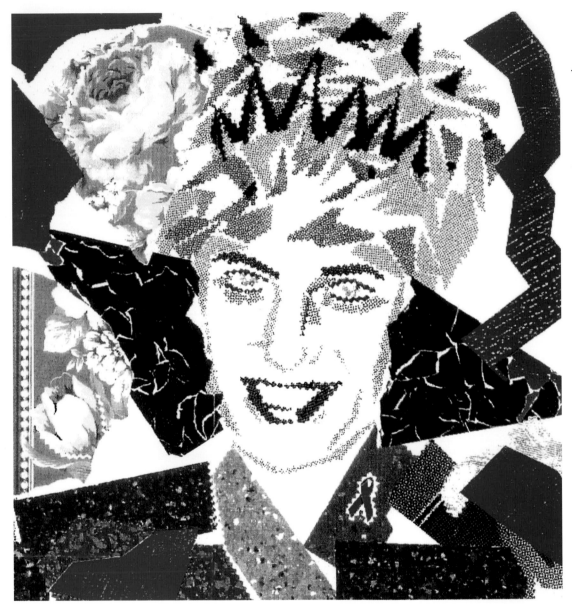

She was clearly nervous when she came in. We did a very short seminar for her and then we took her into the ward. But the moment she started meeting patients she relaxed. And, of course, there was that very famous photograph of her shaking hands with a patient who had AIDS. That was wired all over the world. It made a tremendous impact, just a member of the Royal Family touching someone. It was a colossal impact. It shouldn't have been but it was.

Dr Mike Adler

She took on AIDS because she saw this group of people for whom nothing was being done to help. It is a mistake to think that she is only interested in AIDS and the AIDS question. She cares about sickness and illness.

Angela Serota
Friend

DANIEL MORGENSTERN

Princess Diana – The AIDS Princess
paper on paper
48.5 x 48.5 cm

Princess Diana's work for AIDS was an inspiration to every man and woman around the world. It was so generous and genuinely loving. It came from her heart and soul. She will live on for many other reasons but I think primarily for all the love she so tirelessly gave to our brothers and sisters that are suffering with AIDS. It is an inspiration to us all – I know how much I love her for it.

Dame Elizabeth Taylor

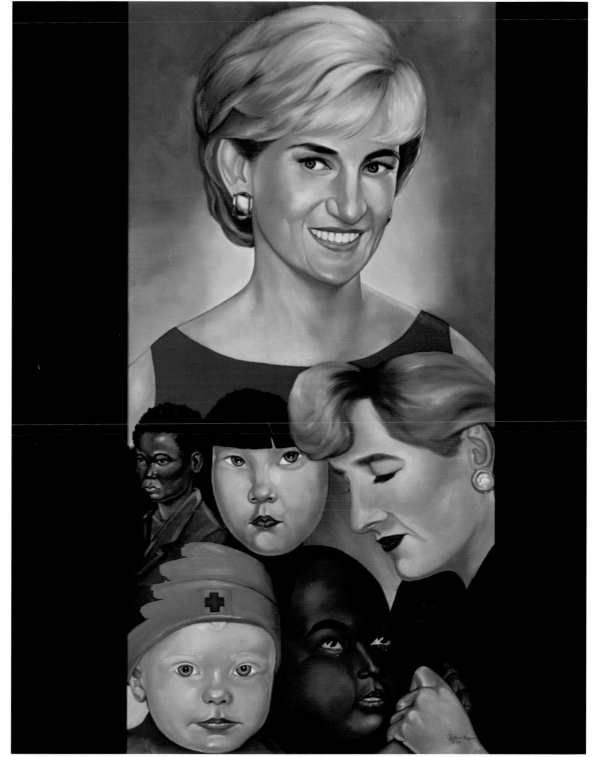

DANIEL HODGES

Diana, Princess of Wales

oil on canvas

61 x 122 cm

In the first seven years of their marriage, the couple made official state visits to 19 countries. At almost every stop, Diana was the star, the one the crowds waited hours to see. Charles was clearly on also-ran, and his resentment was intense.

Barbara Kantrowitz
Newsweek

We'd be going round Australia, for instance, and all you could hear was, oh, she's on the other side. Now, if you're a man, like my husband a proud man, you mind about that if you hear it every day for four weeks. And you feel low about it, instead of feeling happy and sharing it.

Diana

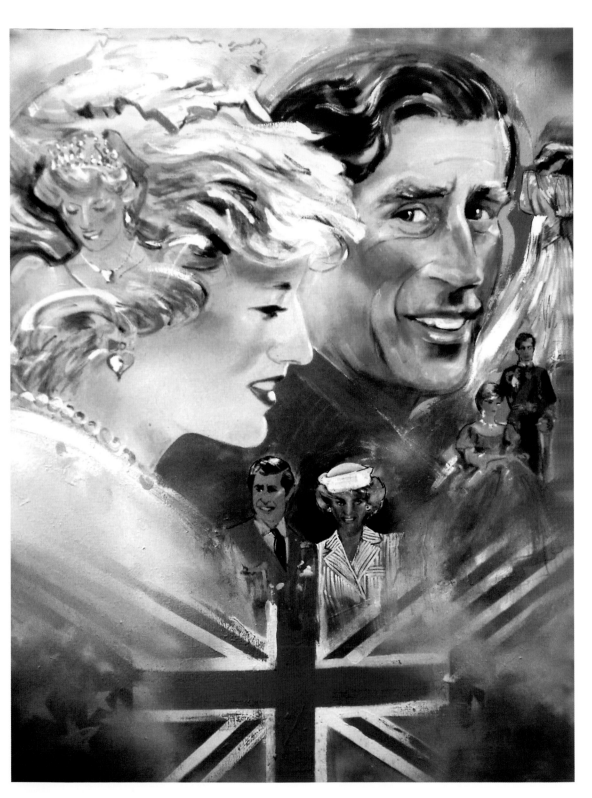

TARANTOLA

Young Love

oil on canvas

76 x 101.5 cm

Anything good I ever did nobody ever said a thing, never said, 'Well done', or 'Was that ok?' but if I tripped up, which invariably I did, because I was new at the game, a ton of bricks came down on me ... Obviously there were lots of tears, and one could dive into the bulimia, into escape.

Diana

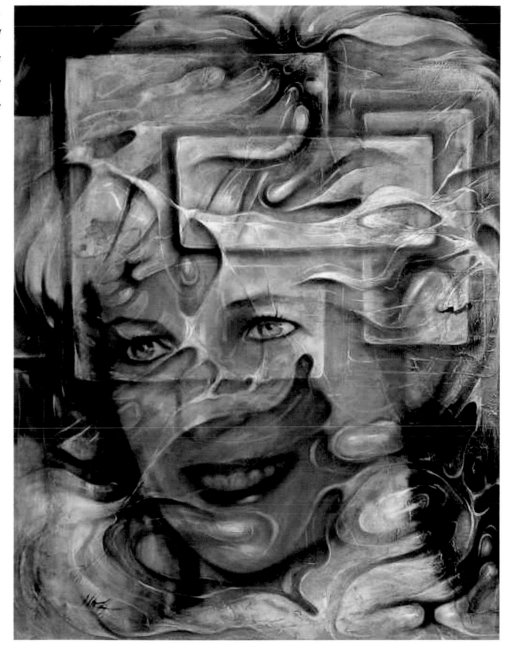

NAZA

Princess Diana

oil on canvas

56 x 71 cm

I was chosen to lead her on to the dance floor to dance 'cheek to cheek' at a gala ball in Washington in 1996 which raised a million dollars for breast cancer charities. Although I'd met her previously this was the first time I got close to her. She made me more nervous than many military opponents but it was fine. I've always considered myself pretty nifty with the foxtrot, but she was niftier.

General Colin Powell
US Defence Secretary

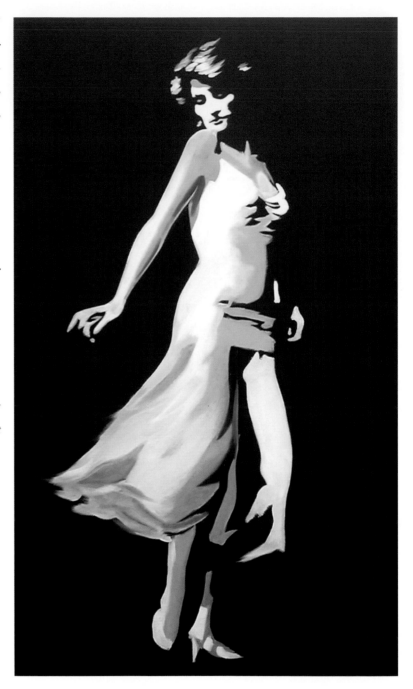

JOE HENDRY

Diana Dancing

oil on canvas

60 x 80 cm

Four years after the wedding, when she was photographed dancing with John Travolta – and also Clint Eastwood and Neil Diamond – at the White House, she looked radiant in the spotlight.

San Francisco Chronicle

For 15 lovely minutes, she made me feel like a prince.

John Travolta

She made my day!

Clint Eastwood

DR T. F. CHEN

Dancing at Moulin Rouge (opposite)

oil on canvas

76 x 101.5 cm

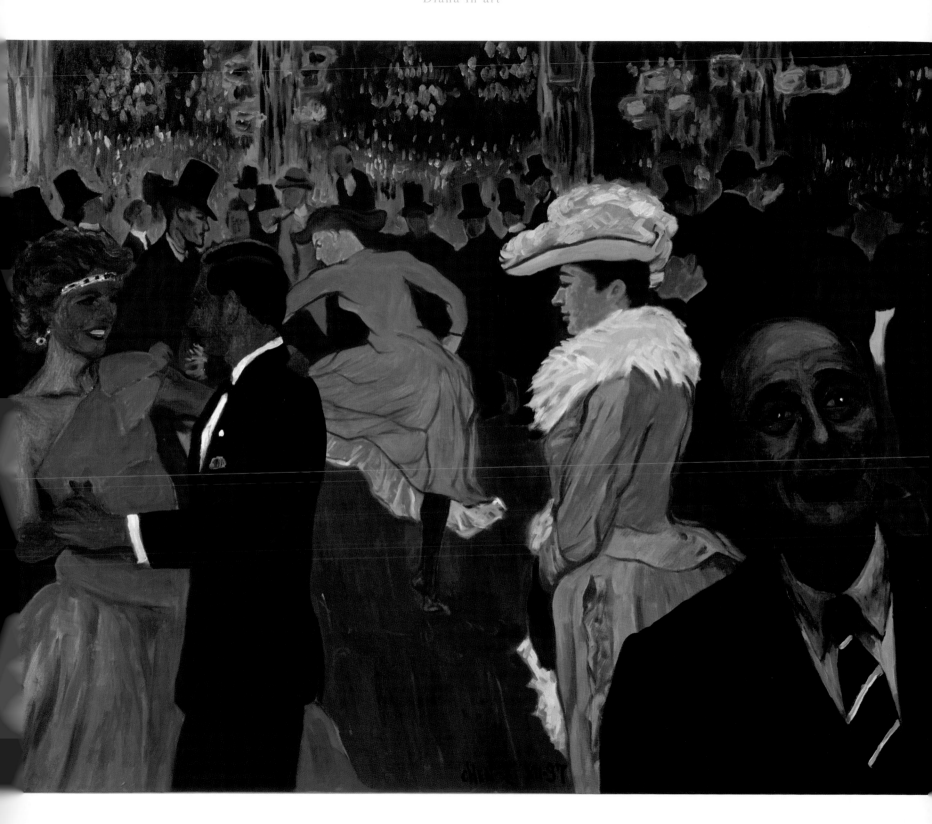

She was our greatest royal personality since Queen Victoria.

Paul Johnson
Journalist

SHAHNAZ

Timeless Beauty
watercolour gouache on Archess paper
76 x 101.5 cm

I think it may have reflected a love-hate relationship with England. Americans don't really like royal families. They only like the 'theme park' aspect of a royal family, the amusement park icons of this little fantasy kingdom across the ocean. She represented both a connection to that and somebody who was rebellious against it. And I think America was founded out of rebellion and they like rebels by and large. And here's one who looked fabulous in an evening dress.

Graydon Carter
Vanity Fair

ROCH DEFAYETTE

Lady Diana, Princess of Wales (opposite)
oil and acrylic on canvas
122 x 152 cm

Diana in art

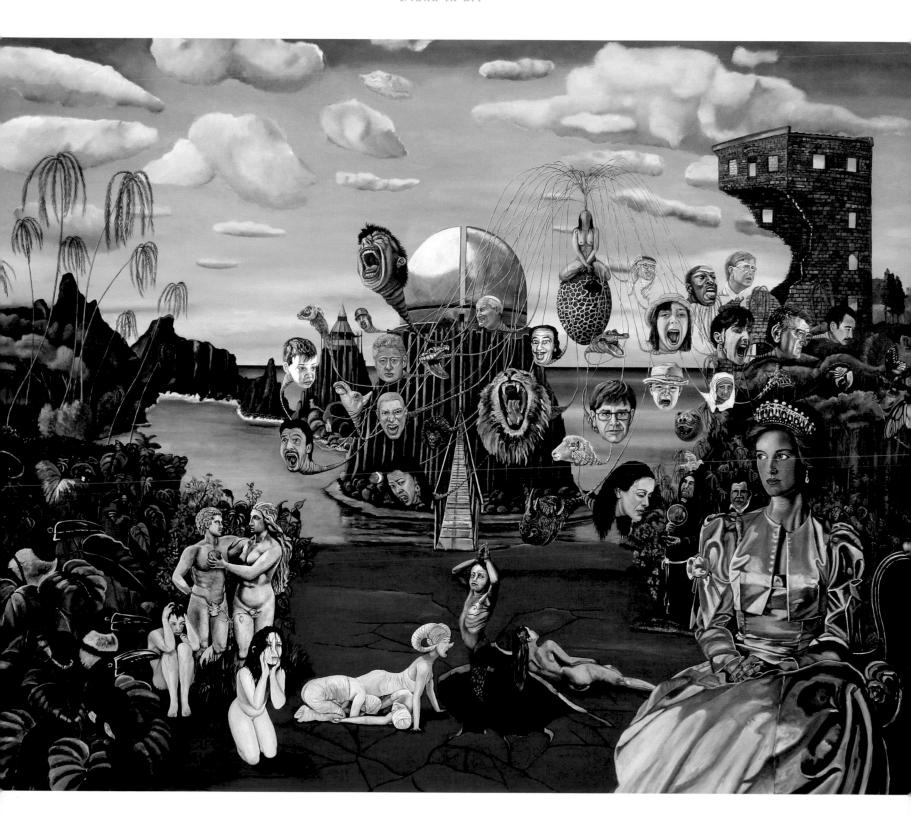

At first, she told me, she had been welcomed into the family and believed that Her Majesty was a great supporter of hers. For her part, the Queen knew that, if handled with care, the young Princess was a great asset to the Royal Family, if not the jewel in its crown, then certainly the sparkle in its diadem. By the time I joined her team, however, Diana had come to be viewed by the Palace as a serious and escalating problem.

Ken Wharfe
Protection officer

DR T. F. CHEN

Presentation
oil on canvas
101.5 x 76

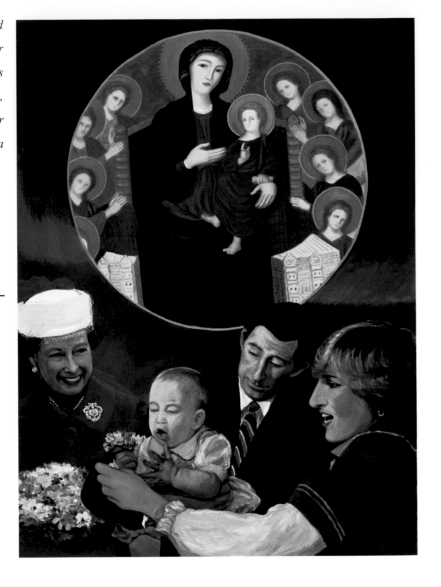

Princess, Mother, Icon ... Diana, Princess of Wales, was all these things and more. The world's most famous woman.

Night and Day

TARANTOLA

Lifecycle *(opposite)*
oil on canvas
76 x 102 cm

We are honoured that she always referred to Duran Duran as her favourite band, as she was certainly our favourite princess.

Simon Le Bon
Singer

We met many times and had become very good friends by the end of her life.

Bryan Adams
Singer

Diana was such an amazing woman.

Mark Owen
Take That

ROCCO A. PESCE

Diana

acrylic on board

46 x 61 cm

The Princess of Wales was both pop icon and the mother of kings, a very modern woman who owed her fame to the most archaic of institutions. Her secret was that she was all these things. Diana was capable of profound change – both in her private life and in her public image – while maintaining a passionate link with her public. Such graceful resilience is a rare gift.

Michael Elliot
Newsweek

ELIANE ROZGA

Diana, Spirit of the Millennium
acrylic and oil on canvas
101.5 x 76 cm

I think the whole business with the Royal Family is that they never seem to do any sensible thinking about broad psychological issues. Diana has entered the family at a time when everything has become democratised in a sense, and yet they still go on as if these things can be picked up along the way. If you're born into the Royal Family, you are groomed, but she came into it late with no training and had to find her own strategy, and yet she blossomed.

Dr Sidney Crown

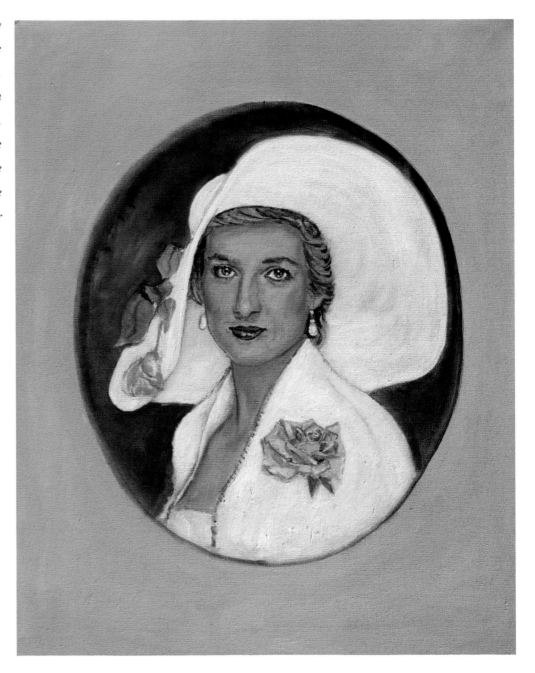

RON KEAS

England's Rose

oil on canvas

40.5 x 51 cm

For the coming year 1995, she had taken on more than 120 domestic engagements and embarked on no fewer than 10 overseas visits, from Hong Kong and Japan to Argentina, Italy and, of course, America. They all followed the model that Diana, in her self-made role of independent ambassador for good works and causes, had worked hard to sustain, and each was a triumph of glamour meshed with compassion.

Andrew Morton

Author

MOHSIN SHAIKH

Princess Diana or Mother Diana?

oil on canvas

122 x 183 cm

She communicated with her body. She managed to make the world fall in love with her through her body language alone. She'd been trained as a dancer. Her body movements and her grace and her style, getting out of cars, looking fantastic in her clothes. And we watched her evolve so swiftly from a shy, fresh-faced English rose into a sophisticated glamour queen.

Camille Paglia
Novelist

She wanted to learn to catwalk. Imagine, the most celebrated woman of our time – glamorous princess, champion fund-raiser, benefactor to the poor, mother of England's future King – learning to strut like a runway queen.

San Francisco Chronicle

JITPIMAN ARPAI

Princess Diana

oil on canvas

71 x 91.5 cm

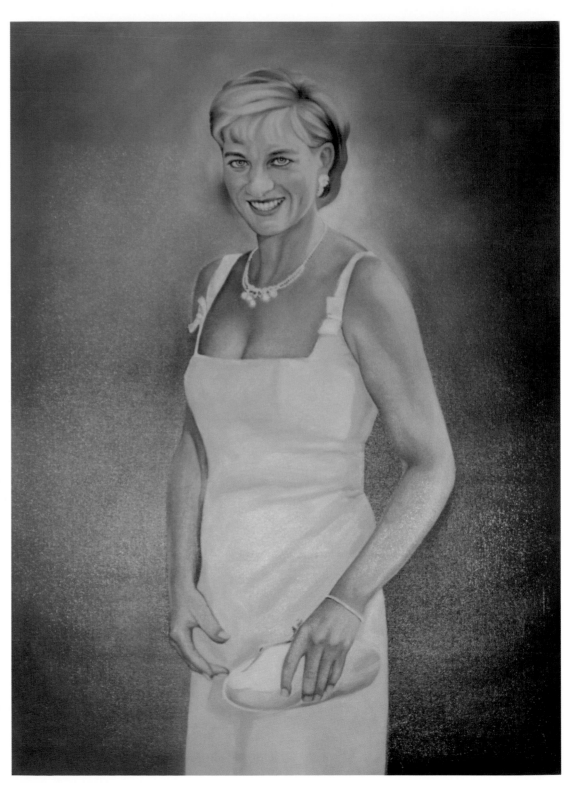

She was one of the family and we came to treat her like our own children. I think it gave her a sense of belonging that she did not have elsewhere. I know I was a mother figure to her and she was like a daughter to me. Diana just became another one of the family. At my house Diana was a girl in trouble and I would listen to her and give her advice if she wanted it. Mostly I listened.

Lucia Flecha de Lima
Wife of the Brazilian Ambassador to London

Courage and persistence in getting up and going on whenever life knocked her to the mat.

Hillary Clinton

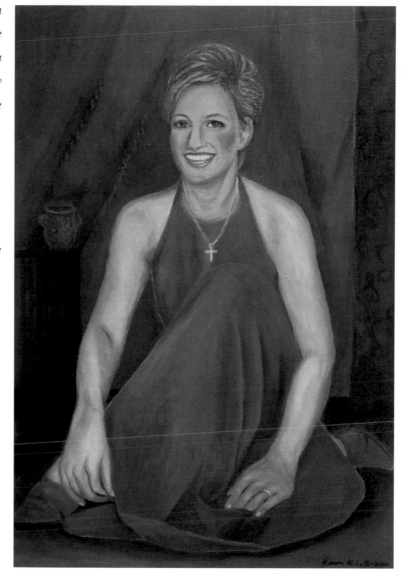

RAUNI ABBOTT

Diana – Princess of Wales

oil on canvas

60 x 85 cm

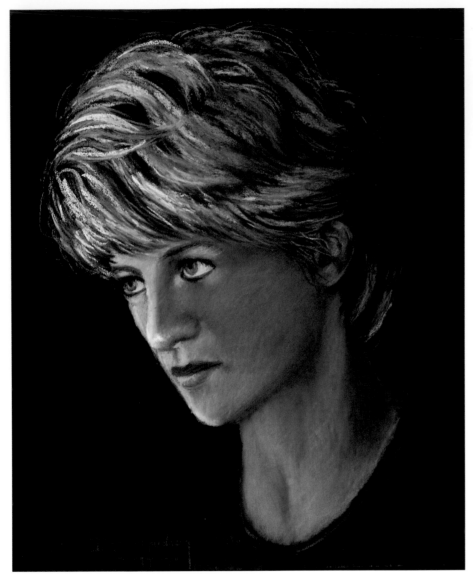

She is kind, generous, sad, and in some ways rather desperate. Yet she has maintained her self-deprecating sense of humour. A very shrewd but immensely sorrowful lady.

Carolyn Bartholomew
Friend

BARBARA HUDSON

Princess Diana in Pastels (above)

pastel on canvas

71 x 91.5 cm

Princess Diana in Oils (right)

oil on canvas

71 x 91.5 cm

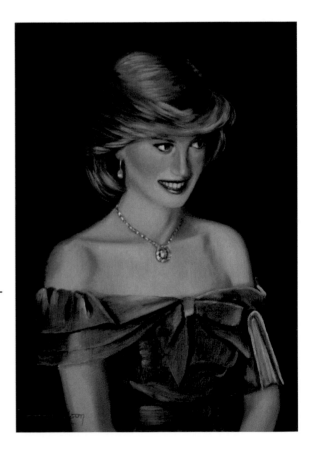

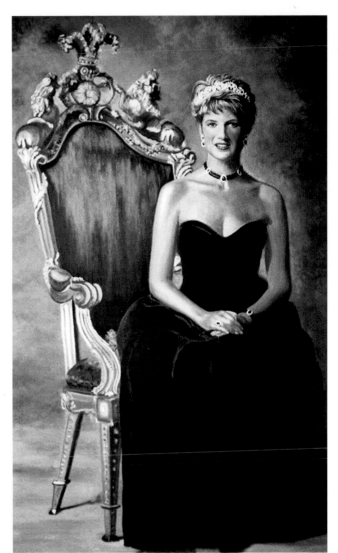

The fascination lay not just in the clothes and galas, the openings and the balls, not just in the Hollywood-style flashbulb glamour of her position, though that was part of it. What held our attention for 15 years was the way in which she coped (or not coped) with her sudden vertiginous ascent into prominence; and, as she struggled, the light she shone on the Establishment at the core of our nation.

Jim White
Journalist

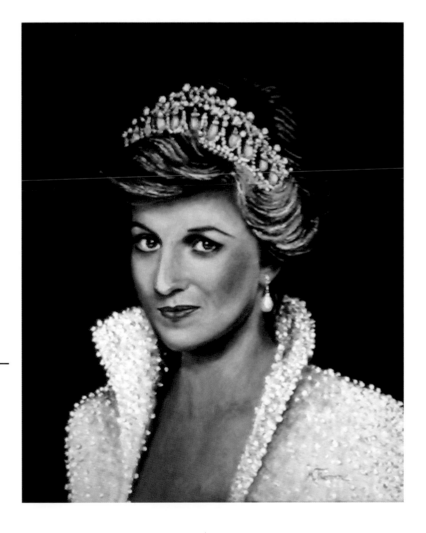

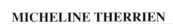

MICHELINE THERRIEN

Princess Diana (above)
oil on canvas
91.5 x 152.5 cm
Lady Di (right)
oil on canvas
51 x 61 cm

The Princess looked stunning in this fabulous headscarf, observing Muslim tradition at what was then the world's largest mosque, in Lahore, Pakistan.

Arthur Edwards
Royal photographer

There was hardly any non-Muslim who worked in a Muslim country with as much devotion and dedication as Diana demonstrated for the sick and poor in Pakistan.

Imran Khan
Former Pakistan Cricket Captain

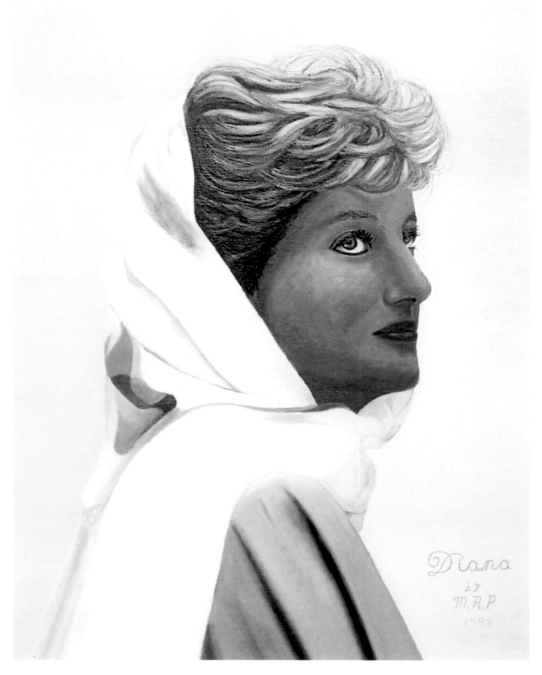

MALCOLM ALAN PRICE

Princess Diana 1998

oil on canvas

51 x 40.5 cm

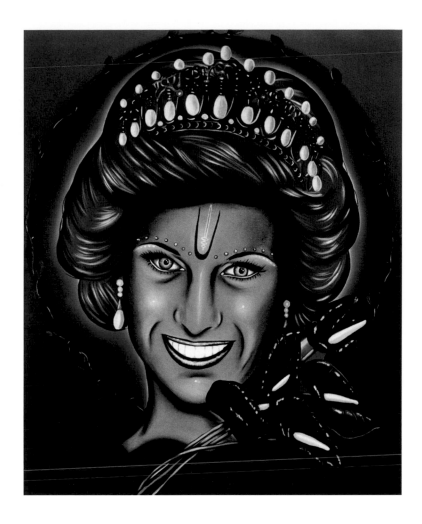

When she went to Pakistan last year she was amazed that five million people turned out to see her. Diana has this extraordinary battle going on in her mind. 'How can all these people want to see me?' and then I get home in the evening and lead this mouse-like existence. Nobody says: 'Well done.' She has this incredible dichotomy in her mind. She has this adulation out there and this extraordinary vacant life at home. There is nobody and nothing there in the sense that nobody is saying nice things to her – apart of course from the children. She feels she is in an alien world.

James Gilbey
Friend

COLIEN LANGERWERF

Lady Di 1997
oil on canvas
120 x 100 cm

This is the point about her, she is not just a decorative figurehead who floats around on a cloud of perfume.

Angela Serota

Friend

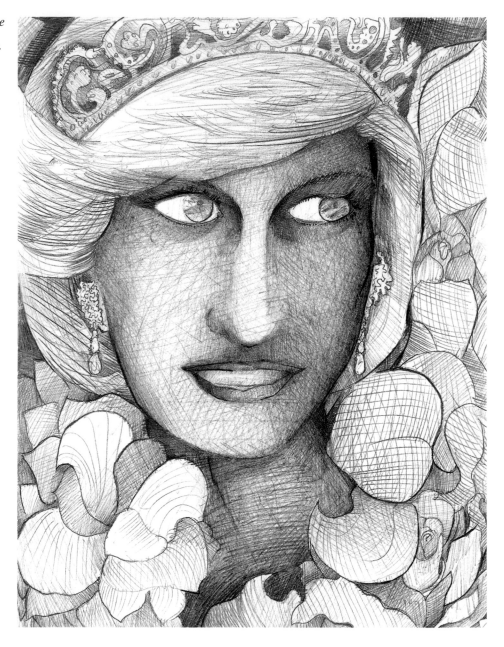

DANNY RAMIREZ

The Rose

pencil on paper

21.5 x 28 cm

Inside the system I was treated very differently, as though I was an oddball. I felt I wasn't good enough. Now, thank God, I think it's okay to be different.

Diana

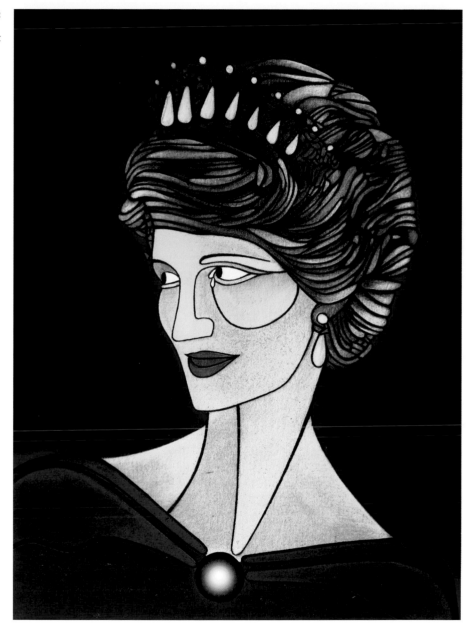

GIULIANO CAVALLO

Beautiful Soul

acrylic, ink on paper

21.5 x 28 cm

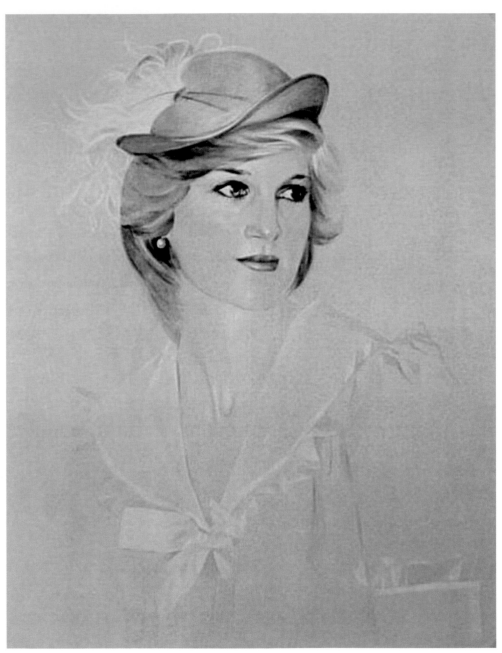

An invaluable national asset. She looked to me for support in just one matter important to her: namely, her overseas work. I was glad, or more accurately, enchanted, to give it.

Douglas Hurd
Former British Foreign Secretary

GEORGE ROE

HRH Princess Diana

watercolour and mixed media

28 x 35.5 cm

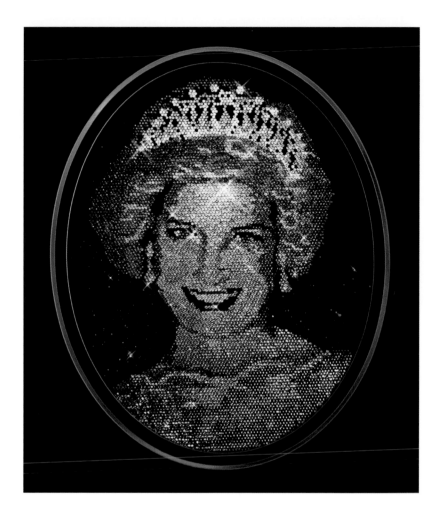

Diana was like a light. I knew Diana for a very long time and I remained loyal to her. She could be difficult, she could be awkward, but you always, always forgave her. She earned your loyalty a hundred times over. And, on good form, she was the most sparkling and energetic person you're ever likely to meet.

Vivienne Parry

Friend

BURKITT AND BURKITT

Princess Diana – Queen of Hearts

Swarovski 10,000 crystals portrait

61 x 79 cm

She said, 'Are you serious? You're staying down here to get that photograph?' I said, 'I am.' She said, 'But you must have lots.' I said, 'Yes, but they're all head down, they're not very good. I want a full face, big, smiling picture for us that we can drop over the whole front page of the papers.' And she said, 'I'll look out of the window tomorrow morning at six thirty, and if you're the only one here I will come down and get into my car. I'll put the window down and let you have some close-ups, with a big smile. And that'll allow you to get home for Christmas.' I said, 'Alright, I'll be here.' And she did it.

Ken Lennox
Photographer

MARK JORGENSON

Princess Di

coloured pencils and

watercolour

20.5 x 25.5 cm

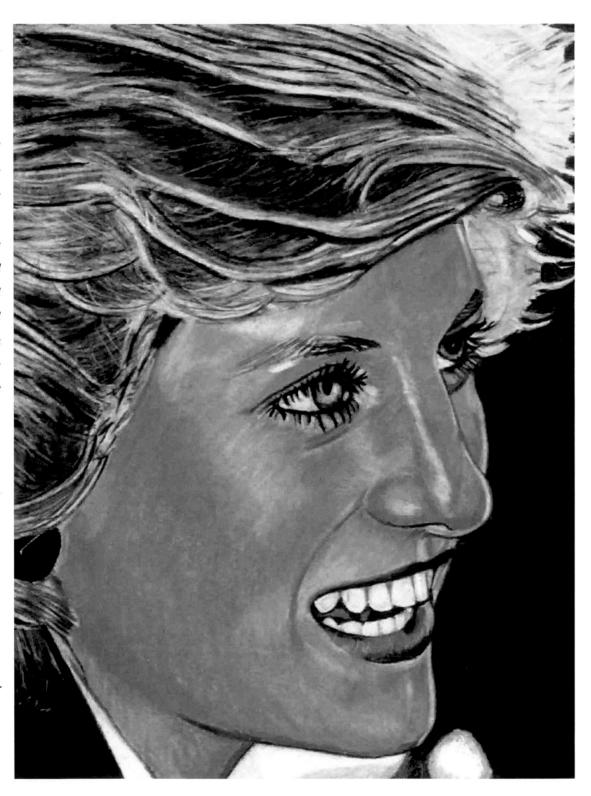

If she had been a Miss World contestant, I am sure she would have said, 'I want world peace, I want to end suffering.'

Vivienne Parry
Friend

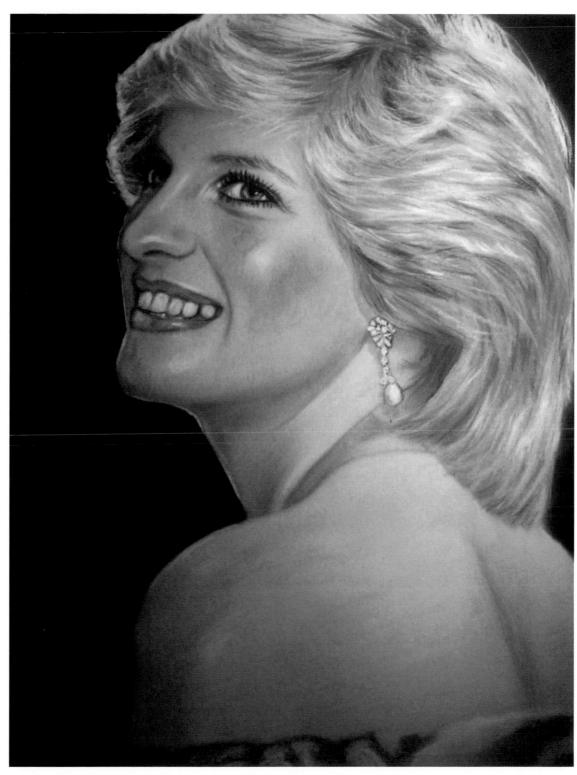

ORLENA ONSTOTT

Profile of a Princess
pastel chalk, mixed media
on paper
28 x 35.5 cm

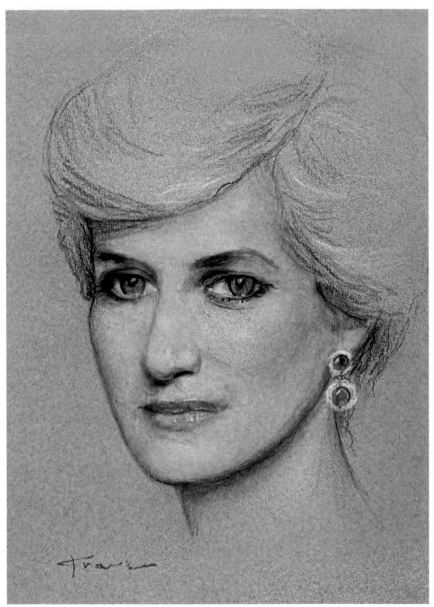

Maybe I was the first person ever to be in this family who ever had a depression or was ever openly tearful. And obviously that was daunting because if you've never seen it before, how do you support it? It gave everybody a wonderful new label – Diana's unstable and Diana's mentally unbalanced. And, unfortunately, that seems to have stuck on and off over the years.

Diana

RICHARD KRAUSE

Definitive Diana
dark pencil on grey paper
40.5 x 51 cm

She managed to get through very difficult parts of life with enormous courage and turned herself from being a very shy, insecure girl, not nearly as pretty as her other two sisters, into a world-class beauty, a world-class fashion model who had a world-class heart. She loved people, and loved helping them. It gave her a tremendous boost, the feeling that she could make a difference. She was a very remarkable, unusual and extraordinary person. Truly an icon of our time.

Raine, Countess Spencer
Stepmother

RICHARD FOSTER

HRH Princess of Wales (1961–97), (opposite)
oil on canvas
114.3 x 88.9 cm
©Private Collection/ The Bridgeman Art Library

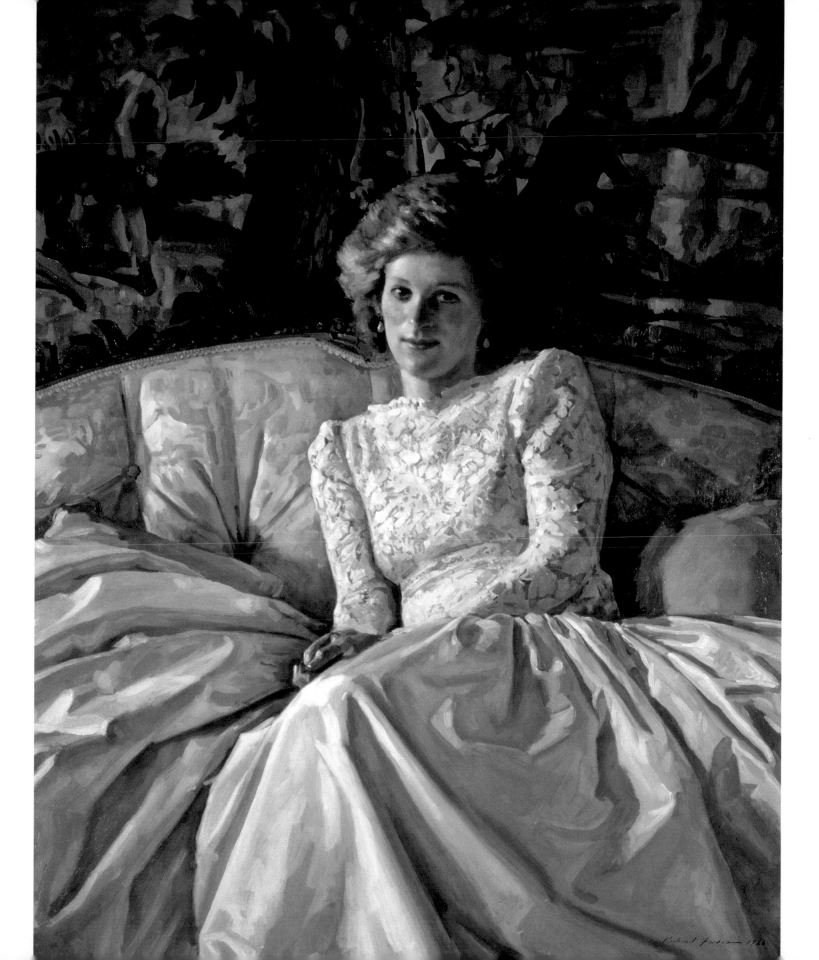

She suddenly became a sort of star, complete star, and I remember going to Australia in January 1983 and being pestered by everybody saying, 'You're related to Diana, this perfect being,' I mean she was almost a goddess at that stage.

Robert Spencer
Cousin

She is a prisoner of the system just as surely as any woman incarcerated in Holloway jail.

Oonagh Toffolo
Acupuncturist and friend

JOANNE ARMITAGE

A Princess, a Star (above)
digital painting
20.5 x 25.5 cm
Diana in Chains (right)
digital painting
46 x 30.5 cm

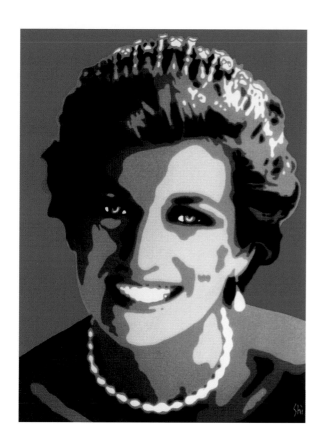

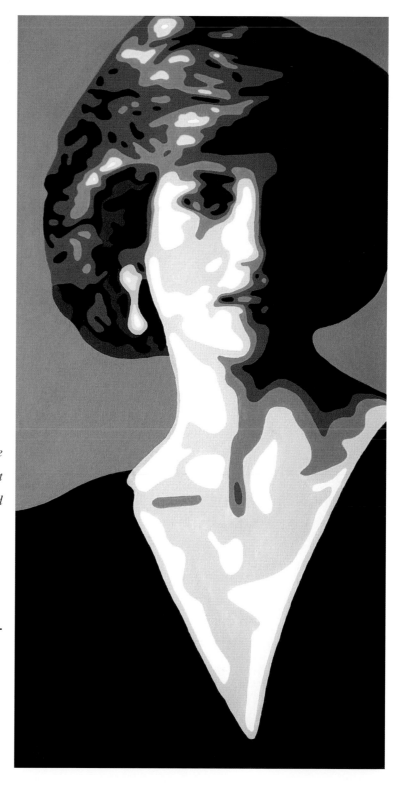

Complicated on the one hand, and simple and naïve on the other. These two co-existed, sometimes awkwardly, and made her life more difficult than it should have been. Her dark side was that of a wounded, trapped animal, and her bright side was that of a luminous being.

Rosa Monckton
Friend

NICOLAS F. SHI

Princess Di *(above)*
acrylic on canvas
101.5 x 76 cm
Lady Di *(right)*
acrylic on canvas
122 x 61 cm

Her head tells her that she would like to be the ambassador to the world; her heart tells her that she would like to be wooed by an adoring billionaire.

James Colthurst
Friend

I don't go by the rule book, I lead from the heart, not the head ...

Diana

DIANE BERUBE

Lady Di – When I Saw her Soul
pastel on velour paper
28 x 51 cm

One of the reasons you never missed a Diana engagement was because you might never see the same look again. In this case she visited a school in East London, wearing an Edwardian jacket, bow tie and with her hair swept up like a 1950s film star. She never repeated that style.

Arthur Edwards
Royal photographer

GIOVANNI GELLONA

England's Lady

pastel and pencil on paper

50 x 32 cm

Her styles, always copied around the world, changed over the years until she found the reduced, seductive look that became her trademark recently and by which we will remember her.

HELLO!

ANDREA BRUNNER

Lady Di

pastel

21.5 x 29 cm

When it comes to glamour, no one can beat royal women. The world's princesses are international superstars who turn heads wherever they go ... Diana, Princess of Wales – Personality: Caring, flirtatious, sensitive, maternal, artistic, healthy and body conscious. Style: Hailed as the most photographed and beautiful woman in the world. Diana is a fashion icon – she now wears Chanel, Versace and Lacroix. Sleek, blonde, well groomed.

MAJESTY

I met her at the beginning when she was married to Prince Charles and, of course, I immediately realised she was really one of the most beautiful girls in the world. Every designer was inspired by her.

Valentino
Fashion designer

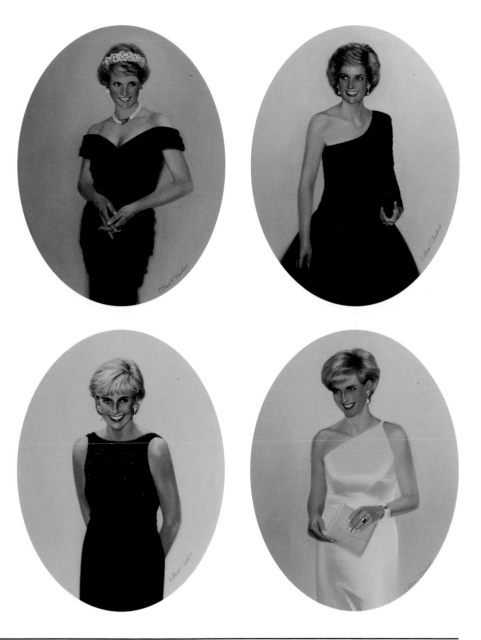

WILLIAM T. CHAMBERS

 A very special Princess *(above left)*

 Radiant Princess *(above right)*

 Forever our Princess *(below left)*

 A most Royal Princess *(below right)*

 all are oil on canvas oval

 all are 61 x 76 cm

When she saw my reflection behind her in the oval mirror on the dressing-table, she would shout, 'Look at this!' It might be kind correspondence – or otherwise – or a magazine photograph or comment by a newspaper columnist. Nobody but dresser, butler, hairdresser, and housemaid was ever invited into this inner sanctum. At these times, she was at her most natural, most relaxed, most easygoing: the princess the world never got to see.

Paul Burrell
Butler and friend

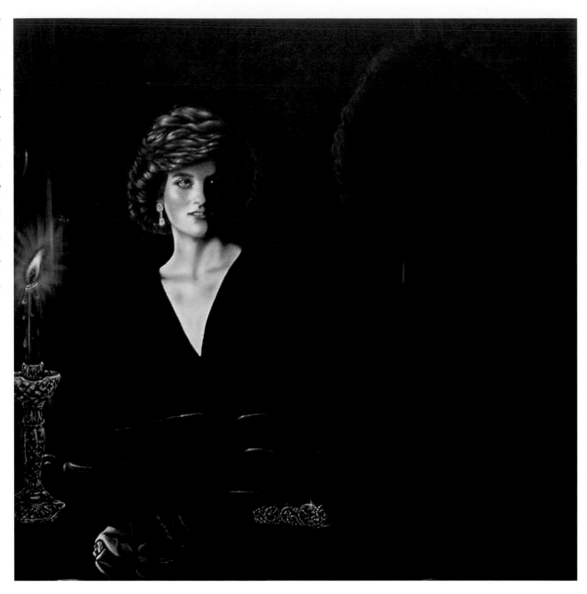

SUE VICTOR

The Rose, Crown and Candle
acrylic on stretched canvas
63.5 x 63.5 cm

Lady Diana was the most beautiful symbol of humanity and love for all the world. She touched my life in an extraordinary way. She can never be replaced and I will always remember her with deep love and joy.

Luciano Pavarotti
Operatic recording artist

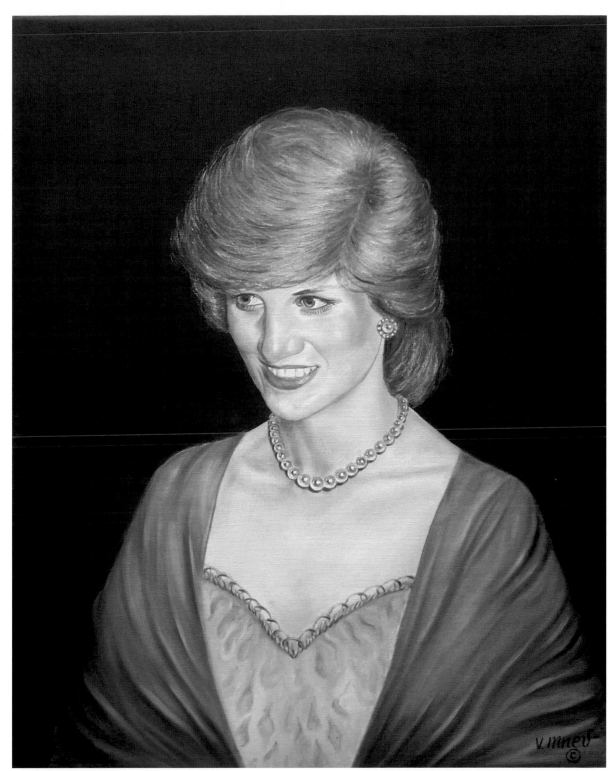

VLADIMIR MNEV

Portrait of Diana

oil on canvas

60 x 49 cm

She has charisma in packets. She's film star quality in that way. I can't describe it, but she's now got presence, which she didn't have when she was younger, and when you put the combination of presence and charisma together, you've got Jackie Kennedy.

Lord Jeffrey Archer
Author

I understand why Jackie married Onassis. She felt alone and in need of protection. I often feel like that.

Diana

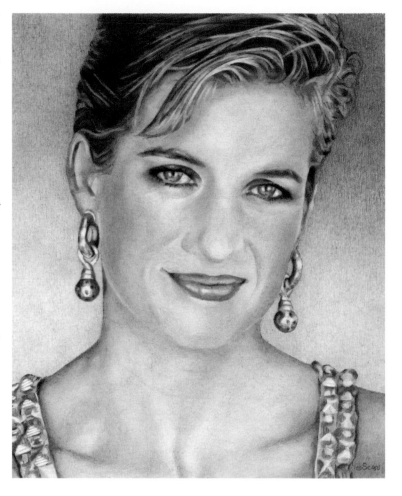

MICHAEL SEAN DUFFY

Diana in Gold
pencil on paper
18.5 x 22 cm

I remember a certain guy who was trying to introduce himself to her and he had obviously prepared a speech in the mirror that morning. And she just looked at him, and before he could get his speech out she just became completely hysterical and laughed and looked at me and I started to laugh and she fell back in the snow and was just laughing so hard.

Jenny Rivett
Personal trainer and friend

YVONNE ONISCHKE

Lady Diana (opposite)
acrylic on canvas
51 x 51 cm

Diana in art

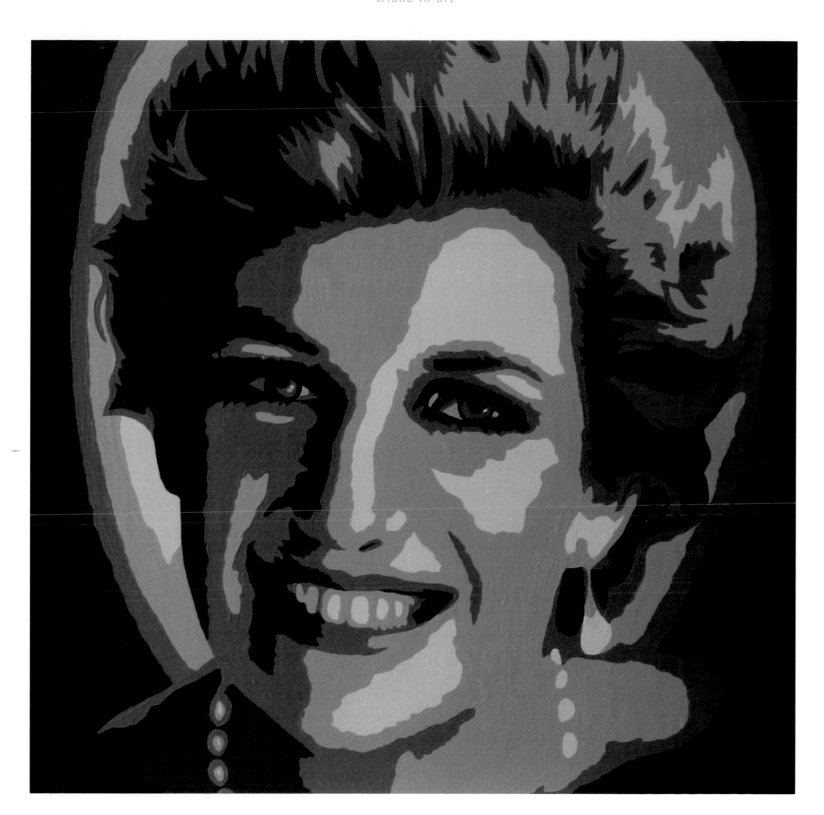

Glamour and tragedy in the lives of Diana and Grace. Two princesses with so much in common. If two beautiful women were ever cast in the same glamorous, heroic, unhappy and ultimately tragic mould, it was the two non-royal girls who became princesses, Lady Diana Spencer and the Philadelphia-born Grace Kelly.

Robert Lacey
Biographer of Princess Grace

Lady Diana was captivated. The two ladies struck up an immediate rapport. In Princess Grace, Lady Diana had found a role model and inspirational figure: an outsider like her, who had married royalty, a film star used to the media glare, a woman in a royal marriage where love was infected by duty.

Paul Burrell
Butler and friend

CHERYL PETERSON

Diana, Princess of Wales
chalk pastel on charcoal paper
30.5 x 45.5 cm

They say it is better to be poor and happy than rich and miserable, but how about a compromise like moderately rich and just moody?

Diana

The Princess is very energetic. She doesn't amble, she swoops and she's fast. It became quickly apparent that she was very funny.

Meredith Ethering-Smith
Christie's Creative Director

VAN LAN NGUYEN

Princess Diana

oil on canvas

28 x 35.5 cm

I was in rehab and Diana called me up to say she would visit soon. I had never met her before. Then one day Diana comes to my home and she is sitting in my living room, it was so surreal. She gave me lots of advice and told me to be strong. Listening to her definitely changed my life for the better.

Michael Barrymore
TV presenter

WILLIAM T. CHAMBERS

Princess to the World
oil on canvas oval
61 x 76 cm

When Diana got involved doors opened because people were interested in the subject purely because she took an interest in it. Schools started taking an interest and schoolchildren would communicate with other children, pen pals in many landmine war-torn countries. So there was this great shining light that brought all the attention to such an important cause.

Heather Mills McCartney
Charity patron

BRYAN ORGAN

Diana, Princess of Wales *(opposite)*
acrylic on canvas, 1981
177.8 x 127 cm

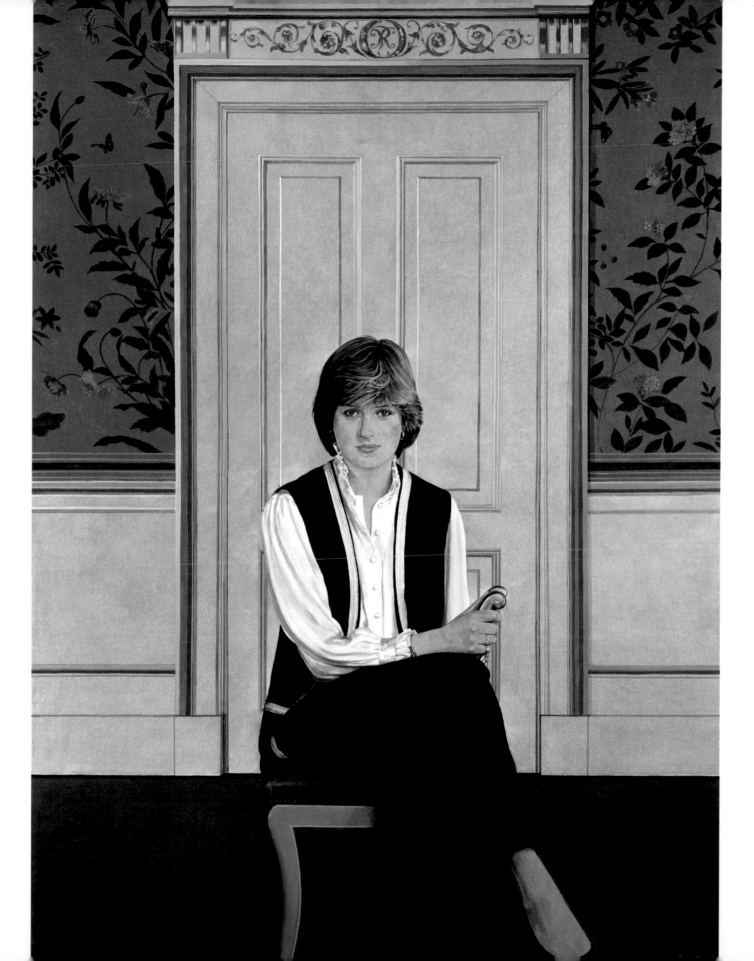

Even in jeans and an old shirt or a jumper she looked great. She had the figure of a supermodel and she made any dress look fantastic.

Arthur Edwards
Photographer

She told me, 'I never wore such high heels but now I'm going to.' She started to have her own identity the last few years of her life. She wore very simple shifts and dresses. She was a picture of beauty, and I do miss her image continuously.

Manolo Blahnik
Shoe designer

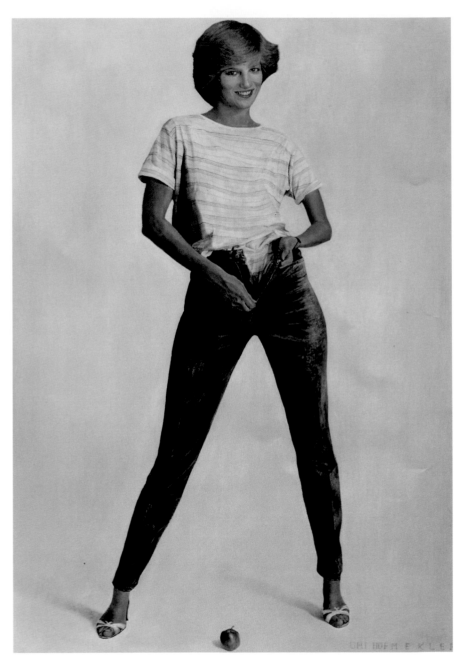

ORI HOFMEKLER

Lady Di

tempera and oil on board

70 x 50 cm

She had a lot of style and grace; she was very attractive and at the same time unreachable. There was something noble about her. I think she is one of the most beautiful women I have ever photographed, because she had everything: the legs, the face, the personality, and a smile that lit up the room.

Mario Testino
Photographer

JOE HENDRY

Diana in Purple
oil on canvas
60 x 80 cm

She struck me as an incredibly lonely person. She was able to alleviate emotional and physical suffering in so many people, yet retained a curious air of sadness herself.

Will Carling
*Former England
Rugby Captain*

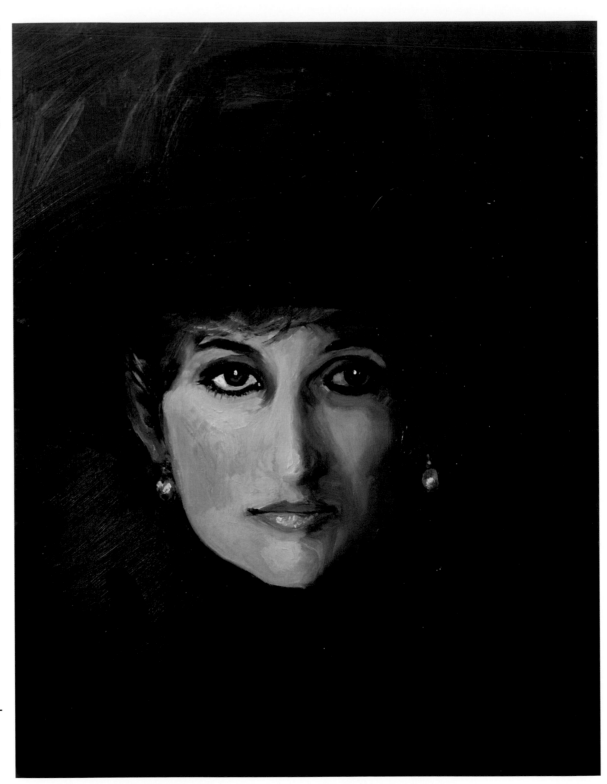

KRISTEN WOOLF

Lady Di in Black

oil on Masonite

35.5 x 46 cm

For a long time it seemed as if she was still searching for her own style. Recently, she seemed to have found that, strictly controlling any temptation to overdo things and favouring those clean, modern lines to set off a great face and figure.

Giorgio Armani
Designer

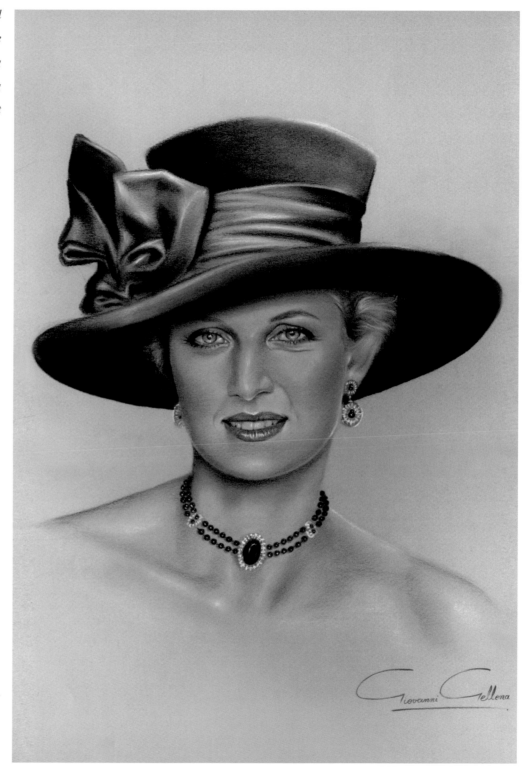

GIOVANNI GELLONA

Diamond of Wales

pencil on paper

50 x 32 cm

She was courageous enough to stand up to the most powerful people in Britain, and give them a two-fingered salute. She said, 'I'm not going to be the quiet, long-suffering little wife and put up with what other royal wives have put up with for centuries.'

Judy Wade
Journalist

BERYL BEAUPRE

Princess Di

acrylic on board

22 x 31 cm

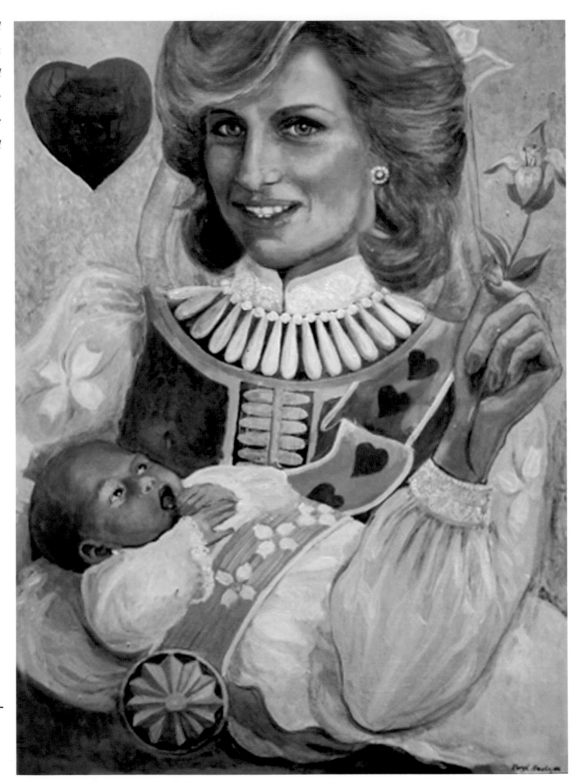

Wherever you looked around the apartments, images of William and Harry, at all ages, stared back from virtually every surface: on the piano in the drawing room, on the Princess's desk in the sitting room and on the table in the corner, on the walls of the corridors. These boys were, quite simply, her life.

Paul Burrell
Butler and friend

I hug my children to death and get into bed with them at night. I always feed them with love and affection. It's so important.

Diana

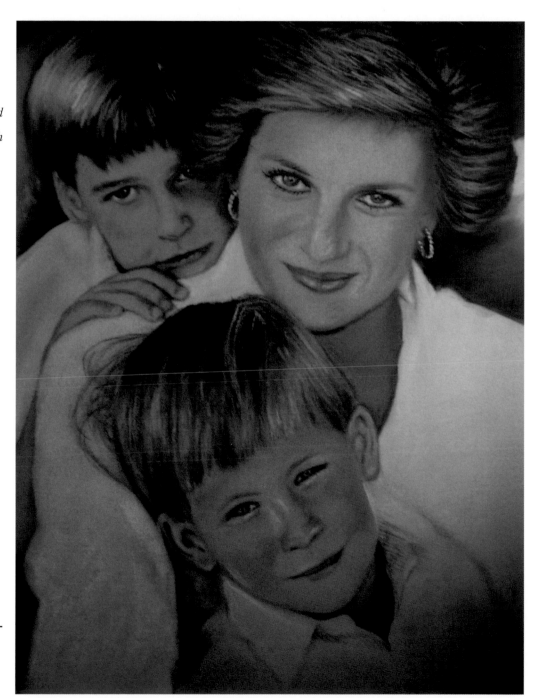

ORLENA ONSTOTT

Mum's Top Job

pastel chalk

21.5 x 28 cm

For a minute or an hour, she made whomever she met feel the sole recipient of her attention. If this was art or artifice, it was of a kind which brought happiness to a host of humanity.

Max Hastings
Evening Standard Editor

MICHEL VINAY

Portrait of Diana

chalk on paperboard

40 x 50 cm

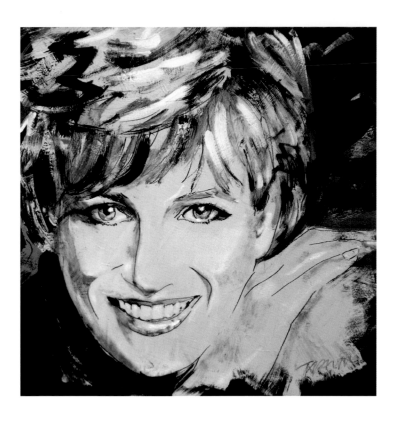

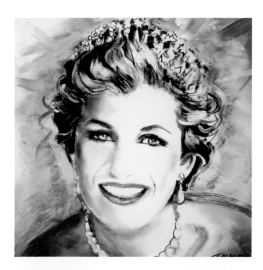

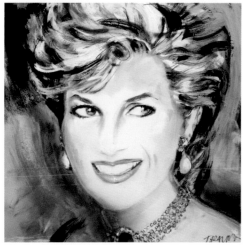

She touched people's lives in such a way that no one who ever met her was the same afterward. I saw it with some of her personal friends and I saw it with members of the public.

Lucia Flecha de Lima
Friend

I want to touch the people and I want them to touch me.

Diana

TARANTOLA

> **Dianapeace** (above left)
>
> **Tiara Diana** (above right)
>
> **Here's Looking at You** (middle right)
>
> **Starry Eyed** (below right)
>
> *all are oil on canvas*
>
> *all are 51 x 51 cm*

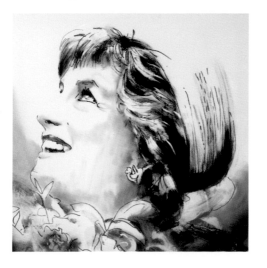

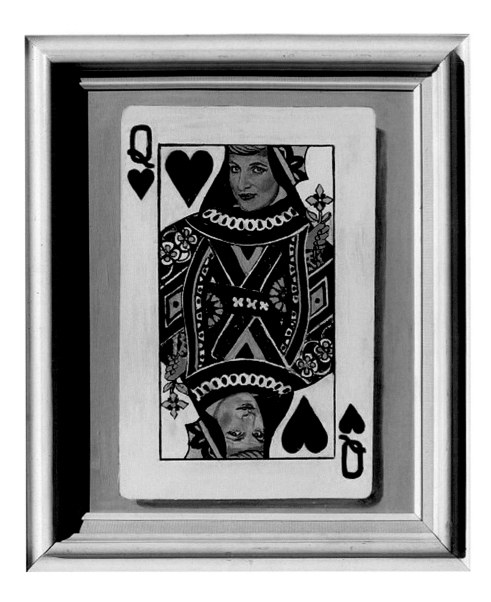

All I want to be is the Queen of people's hearts.

Diana

RON KEAS

Queen of Hearts

oil on canvas

40.5 x 51 cm

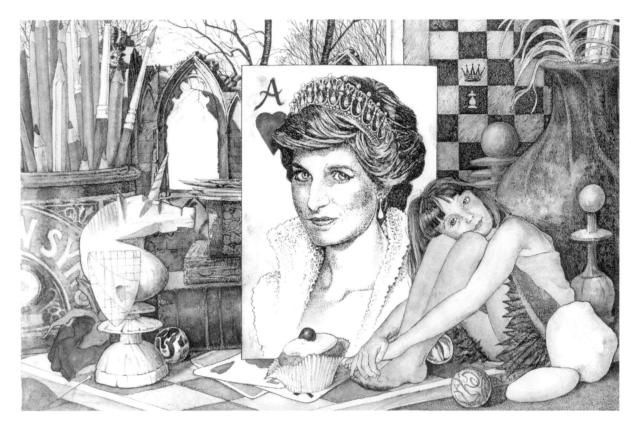

She would never be Queen, but she became ruler of her own heart – and, even in her tragic end, the world's true Princess.

TIME

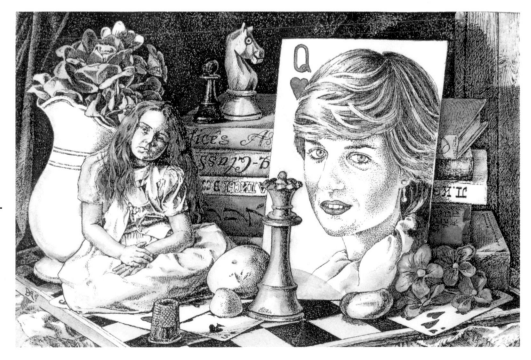

BRIAN PARTRIDGE

Queen of Hearts 1 (above)

pen, ink and watercolour

18 x 28 cm

Queen of Hearts 2 (right)

pen, ink and watercolour

15.2 x 23 cm

Our generation has grown up with so much cynicism about humanity and she made you think again. I really believe that she was a beacon of compassion and hope.

George Michael

I've been running my life like that of Princess Diana. Paparazzi everywhere. When my doctor gave me the news of her death, I fell back down in grief ... and I started to cry.

Michael Jackson

GENE BOSHKAYKIN

The Queen
watercolour, coloured pencil on board
25.4 x 35.5 cm

The letters of support came pouring in. There were thousands of them, many from women who had suffered from eating disorders and accepted their lot in silence. Many told her that they were inspired by her example. She knew that somehow she had touched the heart of humanity and had been able to make a difference. That meant so much to her.

Dr James Colthurst
Friend

REYNALD DROUHIN

Diana Crash (opposite)
mixed media collage
50 x 50 cm

Harry can paint but I can't. He has our father's talent while I, on the other hand, am about the biggest idiot on a piece of canvas. I did do a couple of drawings at Eton which were put on display. Teachers thought they were examples of modern art, but in fact, I was just trying to paint a house!

Prince William

DR T. F. CHEN

Royal Art Studio

oil on canvas

101.5 x 76 cm

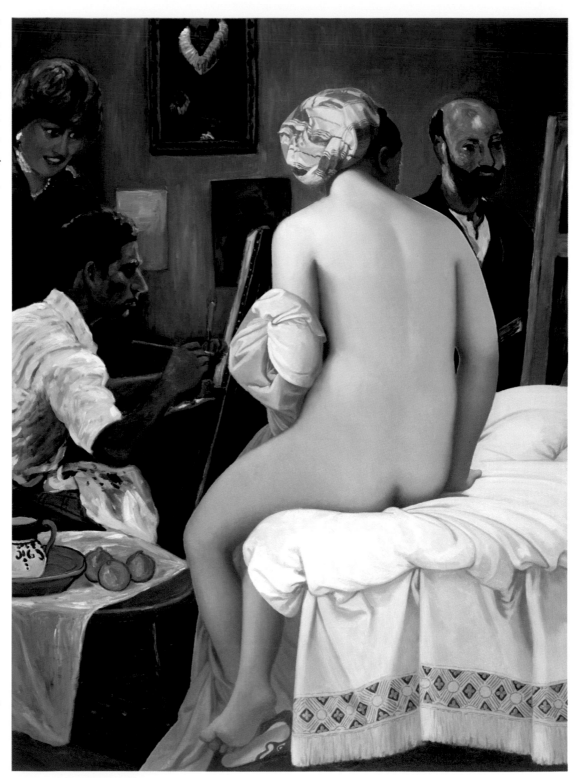

The demure nursery school assistant blossomed into a radiant beauty and became the most photographed woman in the world. But she used that fame to lighten the burden of others, and was loved by millions of people who never met her.

Sir Trevor McDonald

LORI ALEXANDER

Princess Diana

watercolour on board

20.5 x 25.4 cm

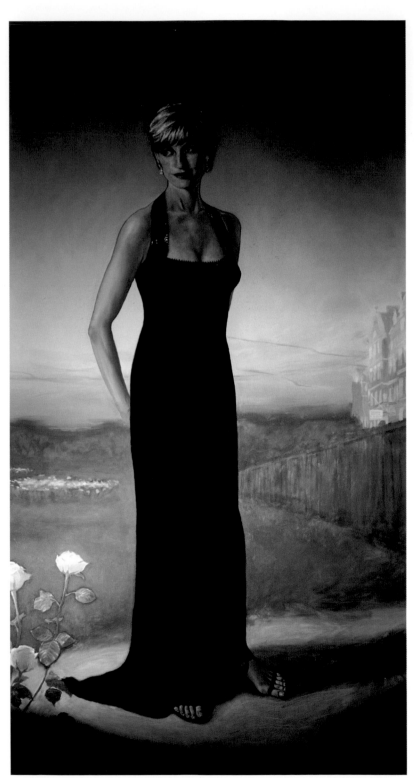

Well, she could be in a great deal of distress but then pull herself together and go out to a public function and be absolutely wonderful and receive tremendous applause and affection. And with that ringing in her ears she would go back to Kensington Palace, very often alone and being served dinner on a tray in her room. And watching television. And it was that, I think, that she found disturbing: the adulation on the one hand and the loneliness on the other.

Lord Peter Palumbo
Friend

She glowed under the rapturous attention, responding as usual to the stimulus of public expectations by producing a flawless display of how to be a royal celebrity. Every gesture, every glance, every stop of every walkabout revealed a professional at the peak of her form.

Patrick Jephson
Former Private Secretary

THEO PLATT

Diana, Princess of Wales *(for the national hospital of neurology & neurosurgery)*
oil on canvas
213 x 122 cm

BEVERLY CHICK

Princess Diana *(opposite)*
pastel on canvas
35.5 x 45.5 cm

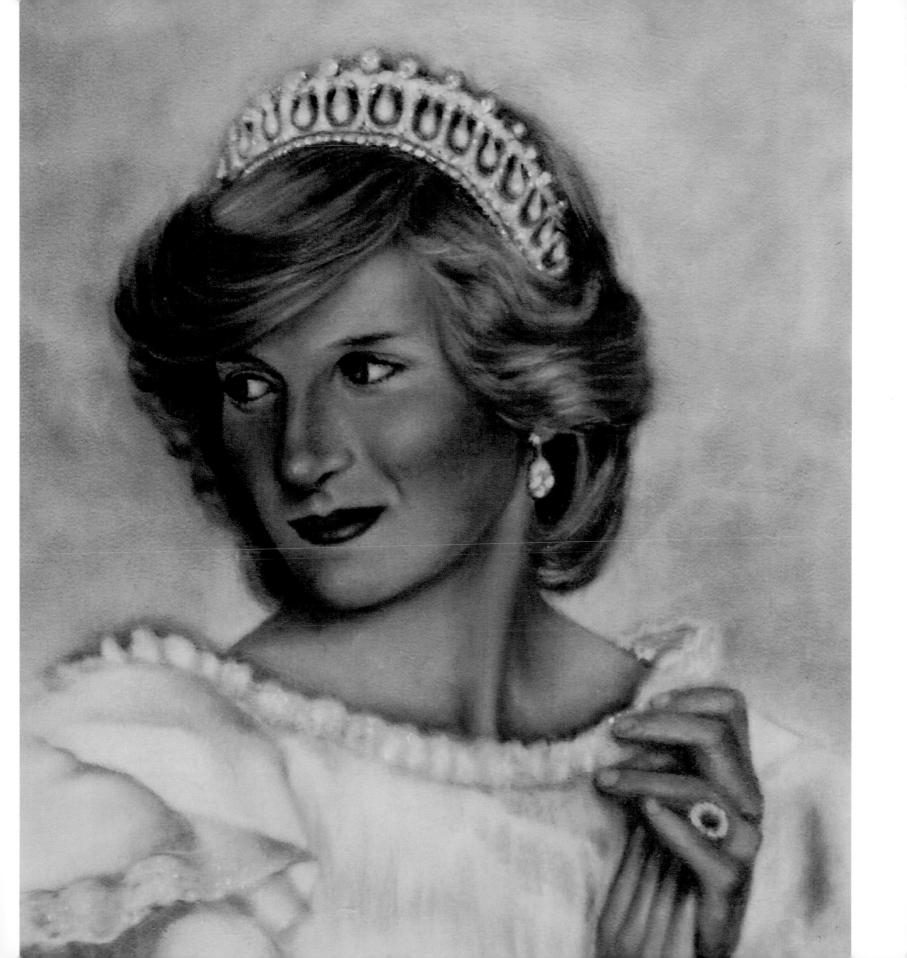

There are many beautiful and stylish people in the world who are icons and movie stars and pop singers, but they don't always draw people from all walks of life to them in the way she did.

Barbara Daly
Journalist

I was very shocked and upset to hear that Princess Diana had died. It is a very sensitive time for all of us.

Kylie Minogue

TONYBOY

 Portrait of Princess Diana
 acrylic with crystal and pearl embell-
 ishments on canvas board
 43 x 26.5 cm

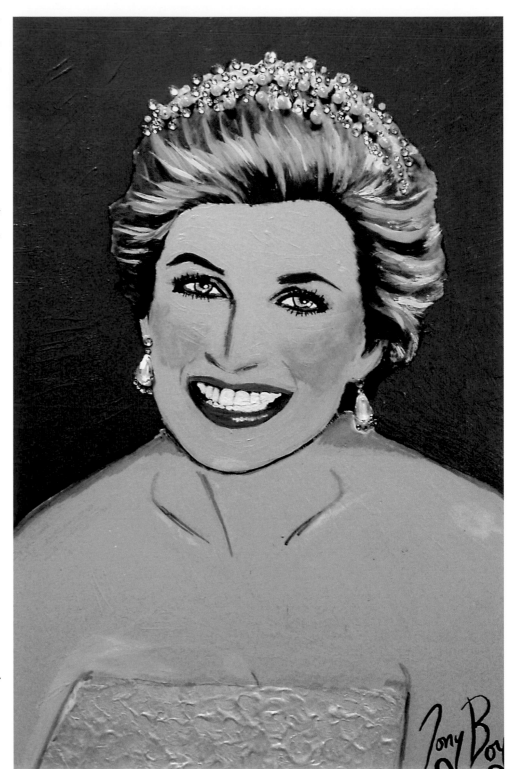

There are various people who have charisma; some of it only comes to life when they're in performance mode, some of it is just there. But Diana was one of these people that quietly just had a way about her that attracted people. It attracted everybody, the camera included. And it wasn't just the fact that she was beautiful, though that does help, of course. As we all know, beauty is only really skin-deep unless there is something else that is also exuding.

Sir Cliff Richard
Recording artist

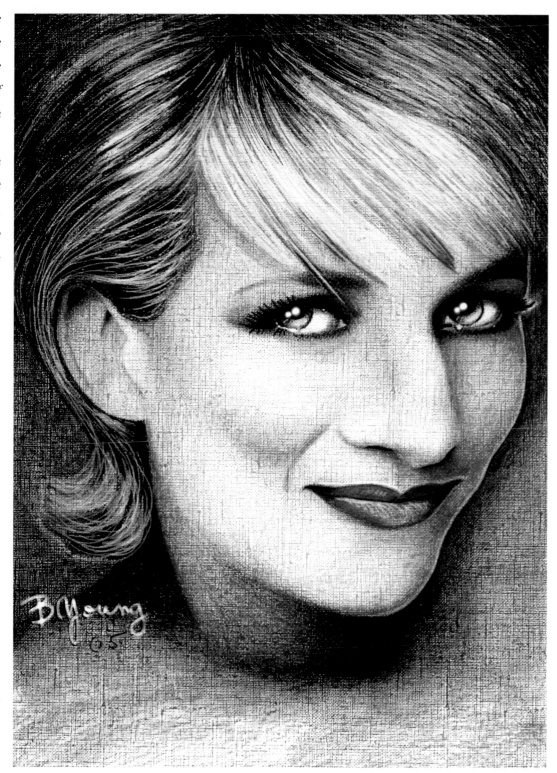

BONNIE YOUNG

Sad Princess

coloured pencil on canvas

21.5 x 28 cm

These were lonely times for her. People wanted to love Diana, the press wanted her image over and over again, Vogue had her on its cover, intellectuals wanted to analyse her and of course we designers dreamt of dressing her. The contrast between this wonderfully desirable image and the reality of her private unhappiness was too much for her to live with.

Catherine Walker
Designer

MARCO MARK

Princess Diana Collage

collage of rag paper, ink, acrylic on canvas

41 x 51 cm

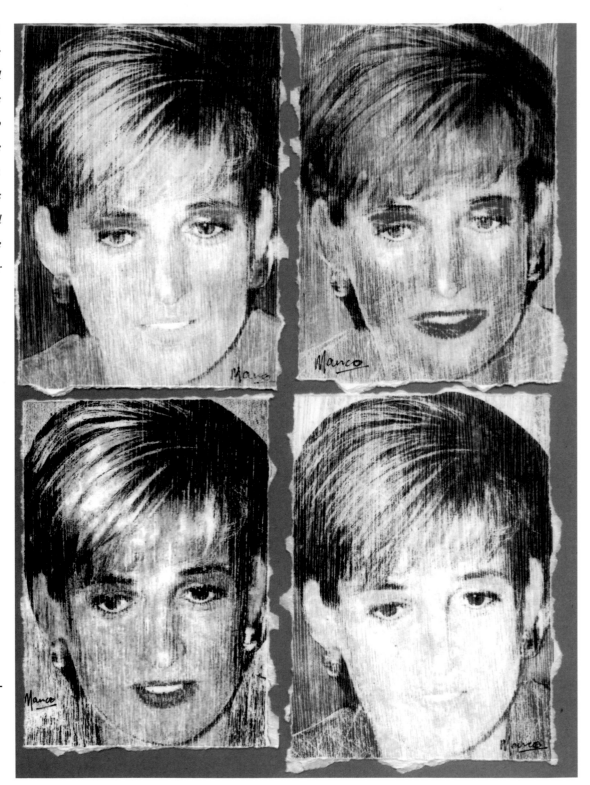

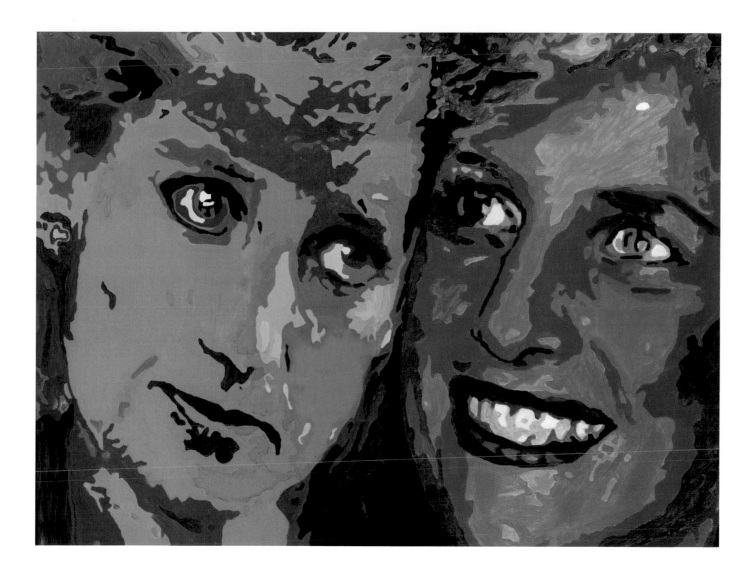

The Diana I knew was full of fun, almost always in search of laughter, not wallowing in self-pity and tears as she is now so often portrayed. There were, of course, dark clouds in her life, but they would soon pass to allow her nature to shine brightly once again.

Ken Wharfe
Protection Officer

SUSAN COCKER

Dichotomy

acrylic on canvas

60 x 80 cm

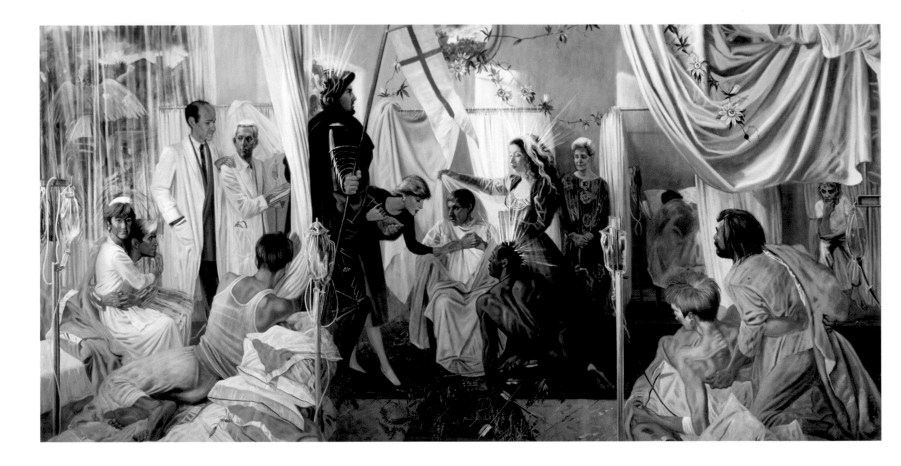

I want to walk into a room, be it a hospital for the dying or a hospital for the sick children, and feel that I am needed. I want to do, not just to be.

Diana

It was an education of the human heart watching her. From the first movement of kindness, and she made kindness tenacious, it was never wishy-washy. From those first days of always talking to people, she used touch. If you look at the photos of her hugging people, it's not phoney, it's not false, that's exactly how it was with her.

Anita Roddick
Founder – The Body Shop

ANDRE DURAND

Votive Offering, 1987

oil on canvas

©www.durand-gallery.com/ The Bridgeman Art Library

I love to hold people's hands when I visit hospitals, even though they are shocked because they haven't experienced anything like it before, but to me it is a normal thing to do.

Diana

She very much touched people's lives. I think when she died, I gather that a lot of people felt 'What happens to me now?' And they felt all their difficulties. But she had some difficulties, major difficulties, in fact, and she was able to cope, so they could too.

Frances Shand Kydd
Mother

JOHN LAPPING

 A Caring Diana

 watercolour and pastel on paper

 20.5 x 25.5 cm

She was very concerned for the poor. She was very anxious to do something for them. That is why she was close to me.

Mother Teresa

She shouldn't be seen as an unreal, mythical figure who combined the sanctity of Mary Magdalene with the selflessness of Mother Teresa. The reason so many sick, vulnerable people were drawn to her was because she spoke openly of her mistakes and weaknesses, her bulimia and her sad childhood. She had defects but she had courage. She faced demons within herself but she battled on and fought back. She died young, but by nature she was a survivor.

Lynda Lee-Potter
Daily Mail

DR T. F. CHEN

Hand in Hand
acrylic on canvas
101.5 x 76 cm

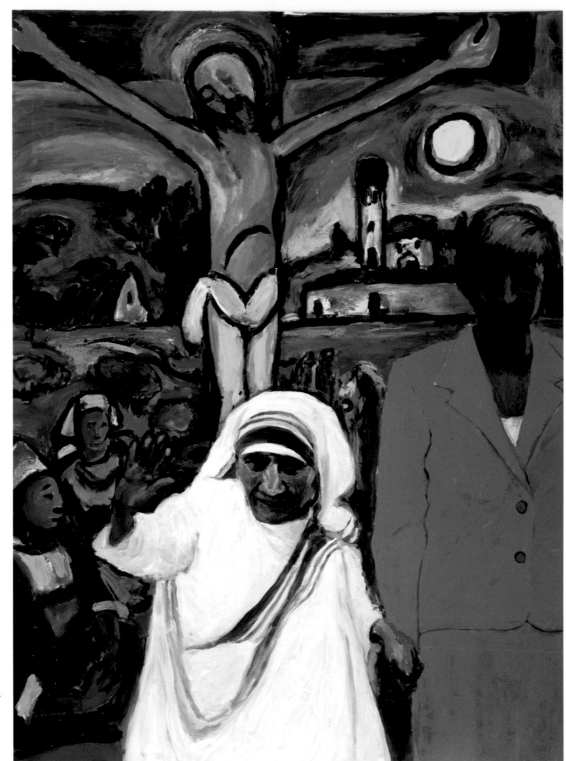

The public... they wanted a fairy princess to come and touch them, and everything will turn into gold and all their worries would be forgotten. Little did they realise that the individual was crucifying herself inside because she didn't think she was good enough.

Diana

It seemed that she was roaming from country to country in search of her personal Holy Grail – peace of mind.

Andrew Morton
Author

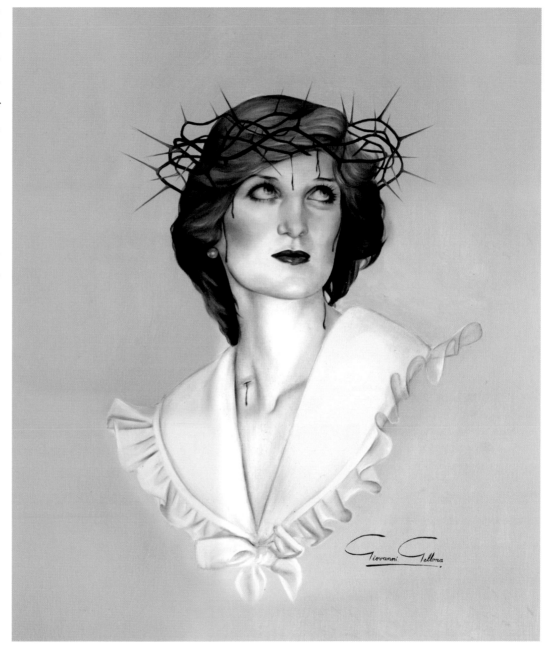

GIOVANNI GELLONA

The Royal Crown

oil on canvas

50 x 60 cm

That tremendous laugh! That joyous sound! And it was wonderful because you wouldn't actually know what she was laughing at, or have any idea at all what had amused her, but at the sound alone you would find yourself smiling, and as you got closer and you heard it more, you'd find yourself laughing. It was a terrific sound.

Muriel Stevens
Schoolteacher

RITA NOVAK

> **Diana's Laugh (above)**
> *acrylic on canvas*
> *30.5 x 40.5 cm*
> **Diana's Smile** (*right*)
> *acrylic on canvas*
> *28 x 28 cm*

She was a very strong person, wilful and capable of making her own mind up about life. The readings I gave her interested her, but she did not see me to know which path she should take.

Rita Rogers
Spiritual medium

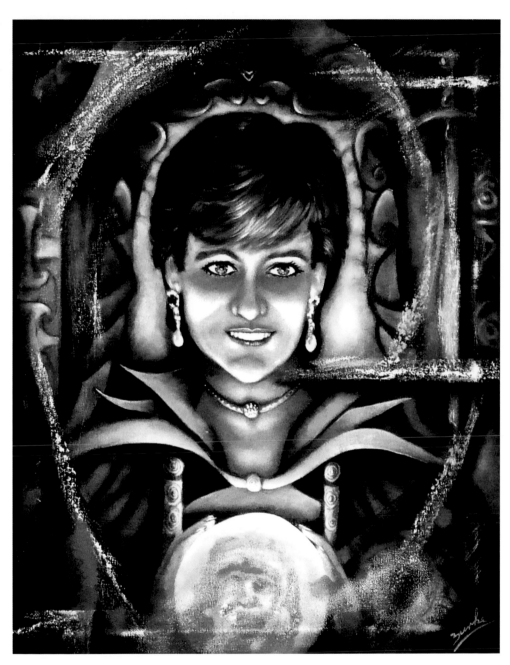

MICHAEL BURKE

Mystic Di

oil on canvas

40.5 x 51 cm

The subtitle on CNN was suddenly saying 'Princess Diana dead'. And for just an hour or so, it felt like November 1963. 'This will be a fixing moment in your lives,' I intoned to my two sons (I was thinking, naturally, about her two sons). 'You will always remember where you were and who you were with when you heard this news.' Princess Diana dead: it seemed brutally inordinate.

Martin Amis
Author

It's exactly like Kennedy's assassination in '63, everyone old enough remembers exactly what they were doing when they heard that Princess Diana was dead.

Richard Madeley
TV presenter

JULEZ FINCH

Diana – in Loving Memory of Patricia Kumar
watercolour and ink on paper
101.5 x 76 cm

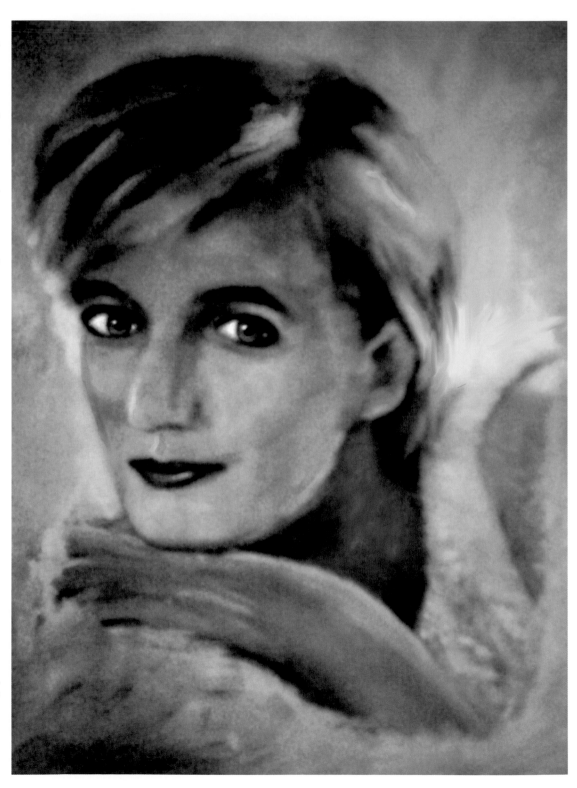

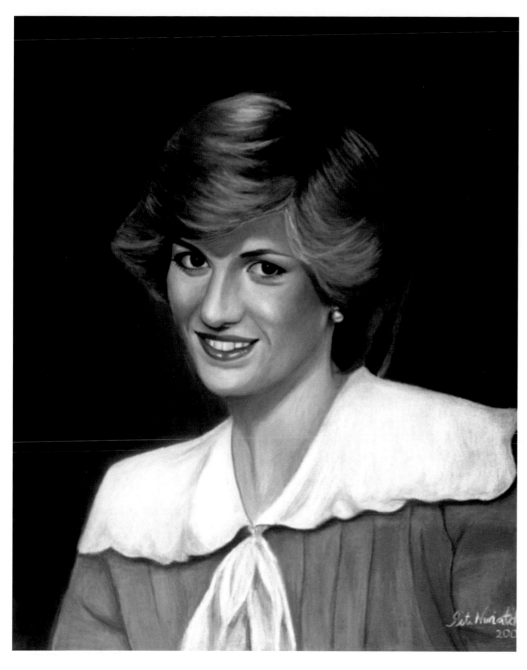

I pay tribute to Diana's personal radiance, courage and, above all, her considerable commitment to so many humanitarian causes.

Roman Herzog
Former President of Germany

I felt on learning the death of Lady Diana that it was profoundly sad that this beautiful young woman, loved by the people, and whose every act and gesture was scrutinised, should end her life tragically in France, in Paris.

Lionel Jospin
Former French Prime Minister

SITI NURIATI HUSIN

Diana in Memory

pastel on paper

49.5 x 58.5 cm

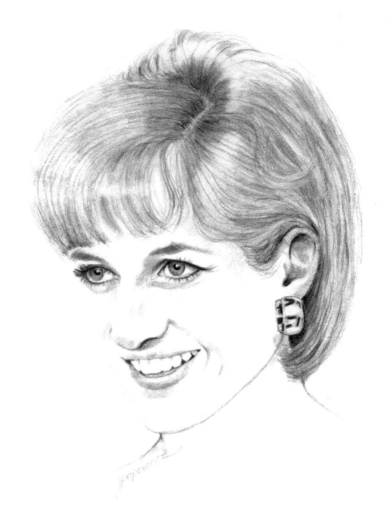

In what further reinforces the power that Princess Diana still enjoys over the world, fans in a matter of minutes grabbed tickets for a pop concert organised by her sons, Prince Harry and Prince William, to commemorate the tenth anniversary of her death. Scheduled for July 1st in London's Wembley Stadium, the concert will feature entertainment icons.

EARTHTIMES

We want it to represent exactly what our mother would have wanted. So, the church service alone isn't enough. We wanted to have this big concert full of energy, full of the sort of fun and happiness, which I know she would have wanted. And on her birthday as well, it's got to be the best birthday present she ever had. And with it we can, by the two of us organising it ... we wanted to have the fact that the evening is all about our mother. The main purpose is to celebrate and to have fun and to remember her in a fun way.

Prince William

JULIE POPOWICZ

Diana

pencil and watercolour on watercolour paper

20 x 25.5 cm

ALI MINER

Diana – Queen of Hearts (opposite)

oil on canvas

71 x 86 cm

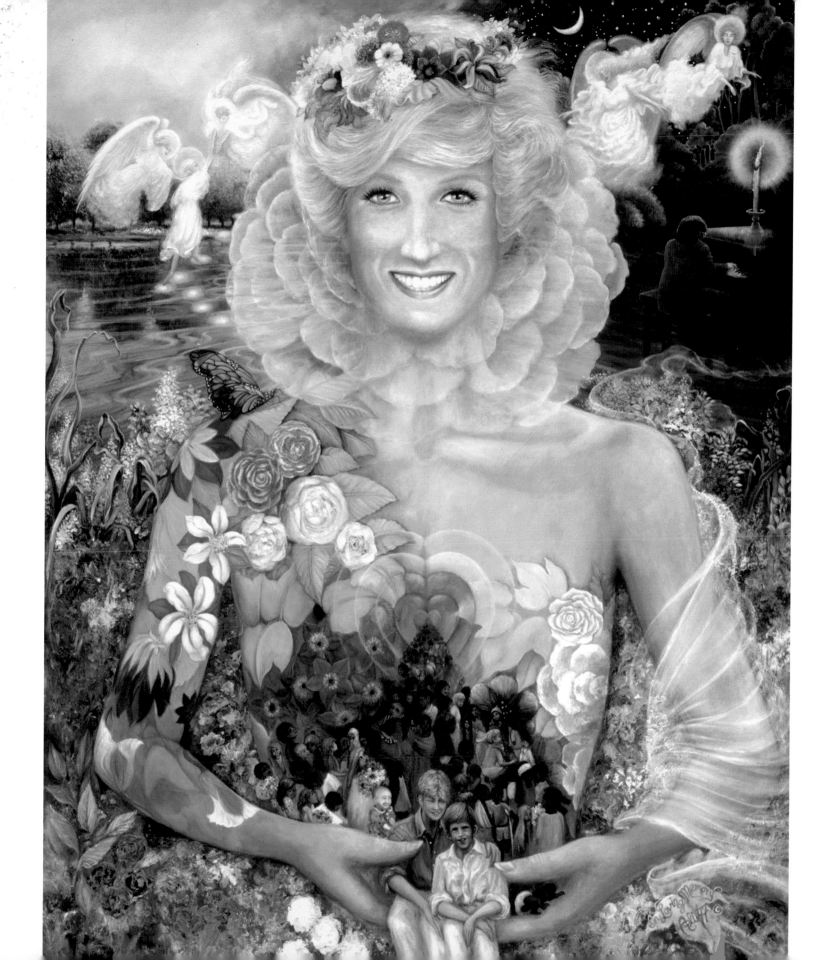

If you're a strong woman in my environment then you're a problem, and I'm a hell of a problem.

Diana

Even today there is a veiled prejudice towards beautiful woman who are intelligent and committed. People have difficulty in accepting that it is possible to be beautiful, to have brains, and to be a person of substance, like Diana.

Bianca Jagger
Model

DOMINIQUE MULHEM

Diana

oil and acrylic on canvas

76 x 101.5 cm

The Duchess of York's presence was a guaranteed pick-me-up for the Princess. Wide-eyed and bounding up the stairs, full of energy, she was a survivor, like the Boss, and there were constant phone calls of support between the two. They'd huddle in the sitting room, deep in conversation or laughing.

Paul Burrell
Butler and friend

I loved her so much. Diana was one of the quickest wits I knew; nobody made me laugh like her.

Sarah Ferguson
Duchess of York

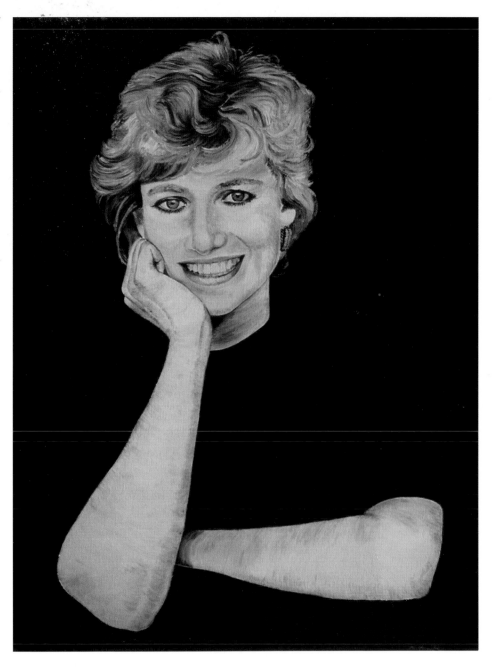

MARC GELIS

Reflection

oil on canvas

51 x 68.5 cm

Diana didn't just attract the lens for so many years because she was a princess. She was the hot shot because she was 100 per cent eye candy – like the supermodels who were gaining fame and fortune at around the same time. People loved looking at her, a passion that never waned, a thirst that was never quenched. Beauty plus royalty! Surely a first. Little wonder that we got addicted to the mix, and the endless pictures served to feed the craving.

Mimi Spencer
Journalist

JOE HENDRY

Diana Slick

acrylic on canvas

70 x 90 cm

She was quite wonderful. I have had the privilege hopefully to show the world the real person behind the princess. It was rather like being let in on a very private secret. I think she became an icon as a result of her many different qualities: her beauty, her style, and her rank. She was fragile and confident at the same time. I have never seen a response quite like that. The basis of her charisma? She liked life and people.

Mario Testino
Photographer

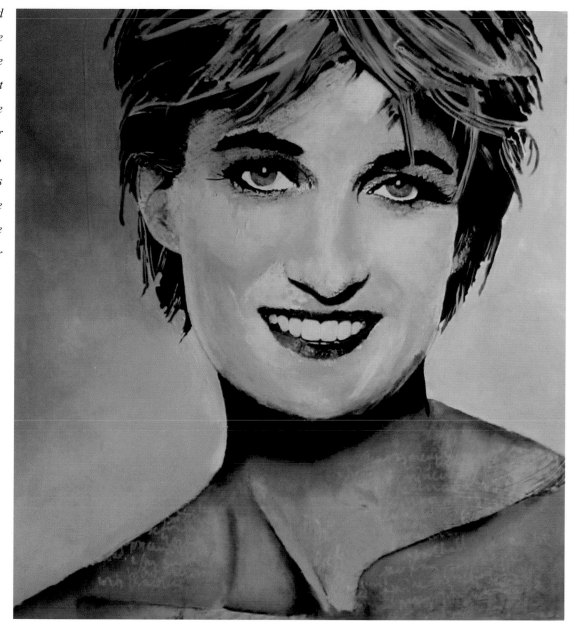

SEAN CANNON

Make me a Channel of your Peace, Diana

oil on wood

152.5 x 183 cm

Alone in the royal family, Diana saw that the monarchy must adjust to survive. Thwarted in life, she may yet succeed in death – if Prince William continues her mission.

William Rees-Mogg
The Times

I was influenced a lot by my visits to hostels with my mother when I was younger. I learned a lot from it, more so now than I did at the time.

Prince William

SANDRO NOCENTINI

A Princess, a Woman

oil on canvas

256.5 x 193 cm

It is hard not to notice that at 36, Diana has died at the same age as that other iconic blonde of the century, Marilyn Monroe. In that, there does seem to be something hideously inevitable about her early death, as if she was always going to become immortal in the way that only stars can.

Nigella Lawson
TV presenter

Everyone said I was the Marilyn Monroe of the 1980s and I was adoring every minute of it. Actually I've never sat down and said: 'Hooray, how wonderful. Never.' The day I do we're in trouble. I am performing a duty as the Princess of Wales as long as my time is allocated but I don't see it any longer than fifteen years.

Diana

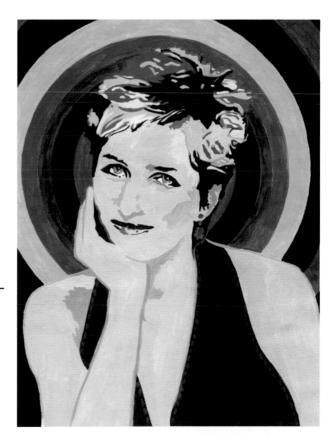

ROGER G. TAYLOR

Iconic Reflection (above)
acrylic on paper
20 x 28 cm
The Vortex (right)
acrylic on paper
20 x 28 cm

Twenty-five years ago today Princess
Diana emerged from her carriage and
walked down the aisle straight into a
nightmare marriage. It was one of those
moments that will forever be ingrained in
our memories. And it's one of those images
that, today, should give us all pause for
thought about lost loves and dreams.

Amanda Platell
Columnist

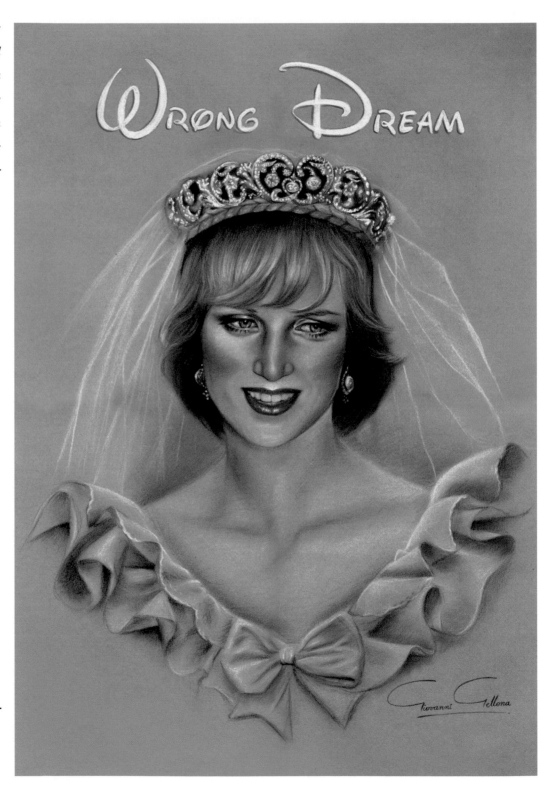

GIOVANNI GELLONA

Wrong Dream

pastel and pencil on paper

40 x 57 cm

She had something I had only ever seen before from Nelson Mandela – a kind of aura that made people want to be with her, and a completely natural, straight from-the-heart sense of how to bring hope to those who seem to us to have little to live for.

Christina Lamb
The Sunday Times

We can all try to follow her example in reaching out to people on the margins of society and welcoming them into our hearts.

Nelson Mandela

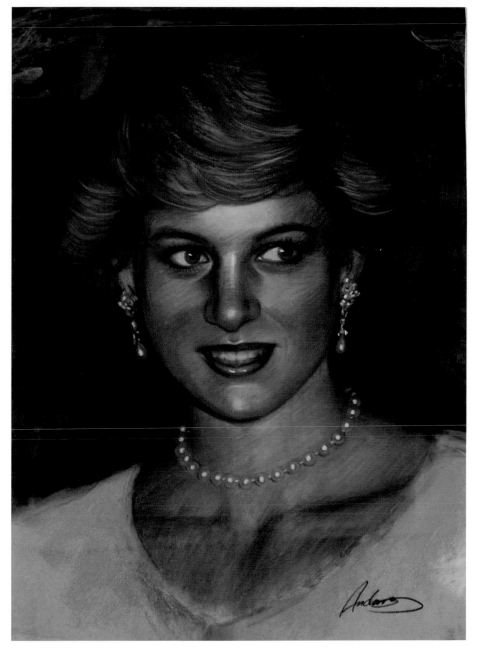

ANDONG WANG

> *Unforgettable*
>
> *pastel on paper*
>
> *33 x 46 cm*

If Diana walked into a room you wanted to sidle alongside and talk to her, she didn't have to do anything.

Sir Cliff Richard
Recording artist

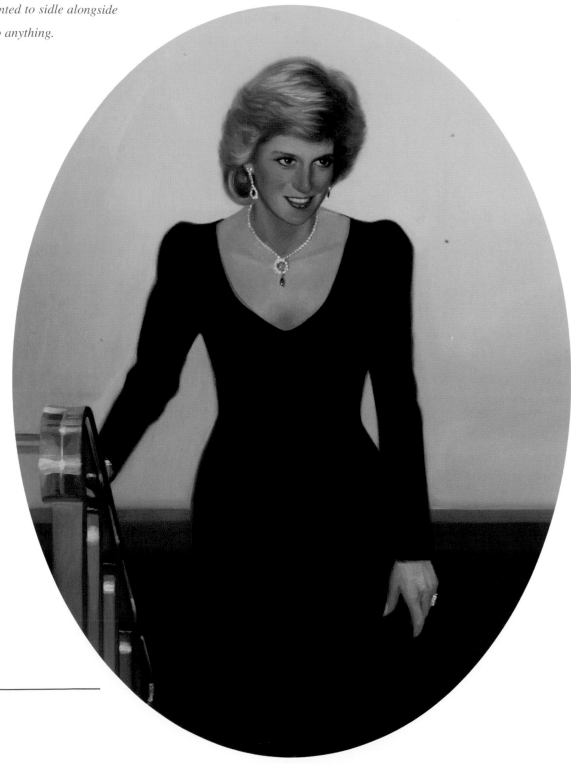

WILLIAM T. CHAMBERS

An Enchanting Princess

oil on canvas oval

61 x 76 cm

She loved Americans and loved America. She felt a sense of freedom in America and was thinking, why not America? The whole of life was opening up for her.

Richard Greene
Lawyer and voice coach

Back home, Americans are watching – and weeping. Because to us, there was nothing 'foreign' about Princess Diana. In America, as in Britain, Diana struck a chord. In my country, as in yours, she connected.

Dan Rather
CBS News

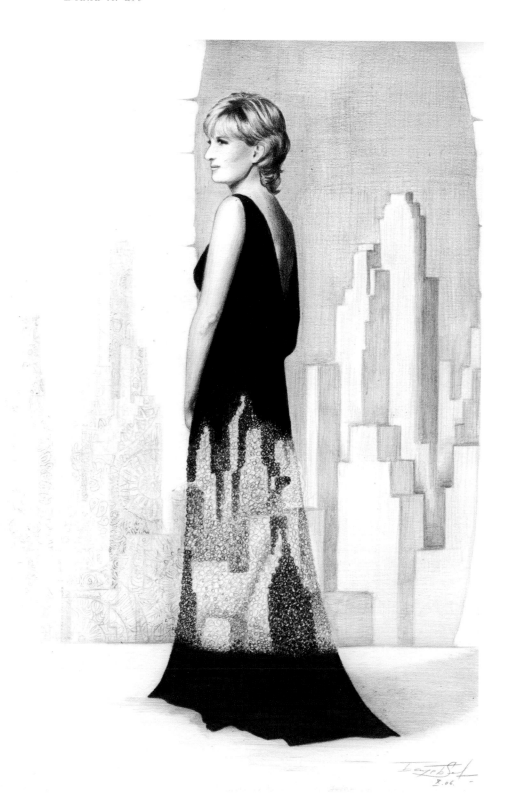

BAUR BERDESHEV

Princess Diana as a
New York Fashion Icon
pencil on paper
40.5 x 51 cm

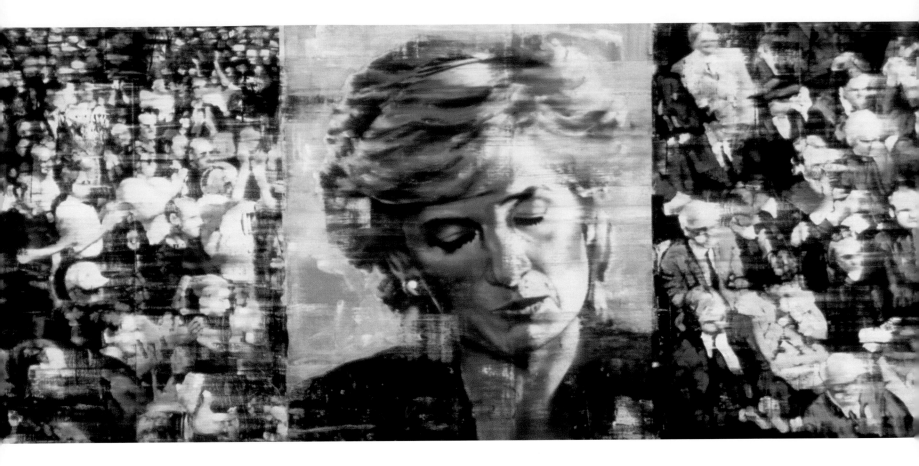

She explained that underneath the veneer of calmness meeting big crowds of people would really make her nervous. She explained what bulimia was to me, which is the first time I'd ever heard of it. She said she wasn't appreciated as much as she should be by those who were asking her to go and meet the crowds and go and be a public figure and go and work for the firm, the firm being the Royal Family.

James Hewitt

Friend

So many people supported me through my public life and I will never forget them.

Diana

JOHN KEANE

Untitled 1999

oil and collage on canvas

© *John Keane, courtesy of Flowers, London*

It was a very difficult film for Elton and I to watch, emotionally, because it covers the last six weeks of the most bizarre summer of our lives. Elton and Diana were estranged at the beginning of that time. They'd had a falling-out, and she wasn't speaking to him. But there was reconciliation, and she came to Versace's funeral and very much wanted to sit with Elton. Then we spent some time with her and they were back on the phone again, and exchanging letters. Then we wake up just weeks later, and she's been killed in a car crash in Paris. It was extraordinary. Watching that film 'The Queen', which shows footage of her arriving at Versace's funeral, was incredibly eerie for us.

David Furnish
Film producer

And let's not forget Princess Diana herself; haunting the whole film in newsreels. This is a very smart story about news, media, myth and image, about getting to the truth, or as near as art can ever get to it.

Jason Solomons
The Mail on Sunday.

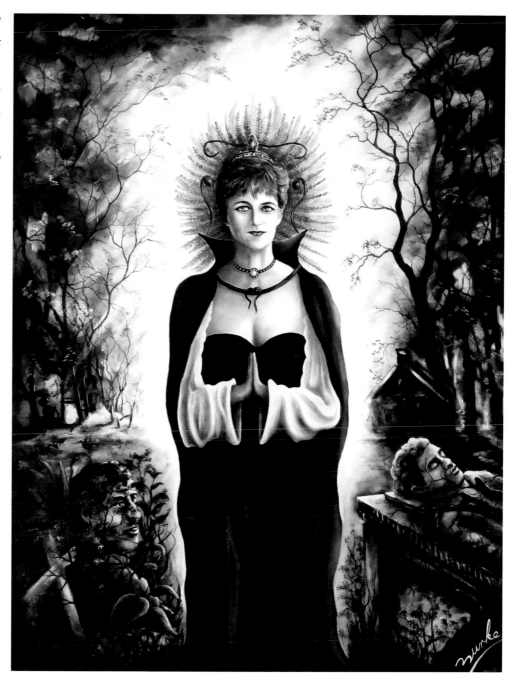

MICHAEL BURKE

Princess of Dreams
oil on canvas
76 x 101.5 cm

Even after she lost the title, Diana was truly Her Royal Highness. It takes nothing but fate to be born a princess, how much harder it is to become one. Maybe one reason we could not take our eyes or our hearts off Princess Diana was that she made it so easy to claim her secretly, subversively, one of our own. Diana played out an old American fantasy, the real-life fairy tale.

Time

CHRISTI GARTON

The Princess

acrylic, spray paint, glitter, crystals and antique glass from 1930's Germany on canvas

61 x 76 cm

The abandoned child, 'shy Di', the gleaming fashion plate, the caring mother, the rejected wife, the royal outcast – all were eventually to merge in a uniquely contemporary figure with many complex layers of apparently boundless appeal. Once this particular Cinderella had stamped her glass slipper, with a crash that echoed around the world, she became an icon to the one group who had so far spurned her, the feminist movement, who adopted her as a role model to speak for all womankind.

Anthony Holden
Author

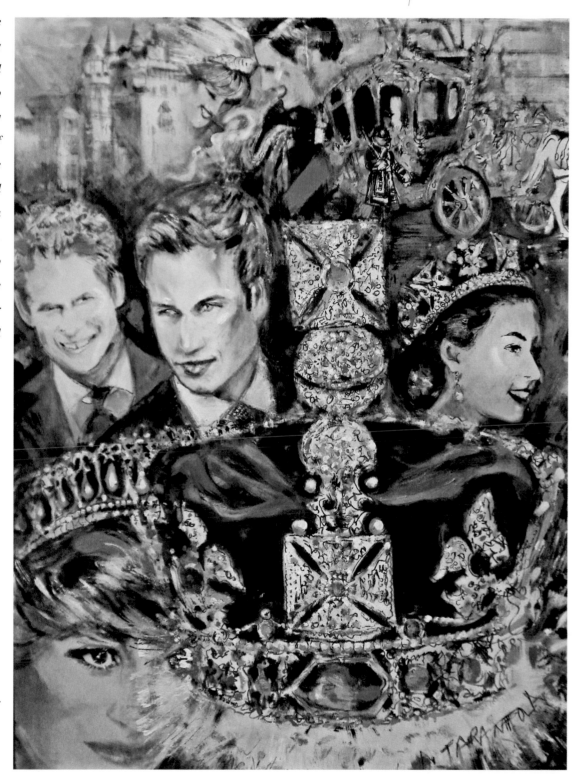

TARANTOLA

The Treasures

oil on canvas

101.5 x 127 cm

She has this American influence on her. I think she has adopted a lot of this confidence and wanting to be a strong woman thing. Remember the recent portrait she had done of herself where she told the artist, 'Make me look strong'? For a British woman to say that is weird. American women love to look strong, they like muscle definition, very modern, very confident. A look that says, 'I'm an individual, I can stand on my own two feet, I don't need a man', in-your-face stuff, which is American.

Mary Spillane
Author

RITA NOVAK

Rider Diana (above)
acrylic on canvas
30.5 x 24 cm
Sailor Diana (right)
acrylic on canvas
30.5 x 20 cm

She often looked as if she were on the verge of tears, in the manner of folk images of the Virgin Mary. Yet she was one of the richest, most glamorous and socially powerful women in the world. This combination of vulnerability and power was perhaps her greatest asset.

Ian Buruma
Author

DR T. F. CHEN

Taking a Sweet Nap

acrylic on canvas

122 x 91.5 cm

It would be fantastic to play her in a movie. She gave back a lot and was such an amazing woman.

Lindsay Lohan
Actress and singer

I had sent her a script for a possible film role. Who knows if she would have ended up a movie star.

Kevin Costner
Actor

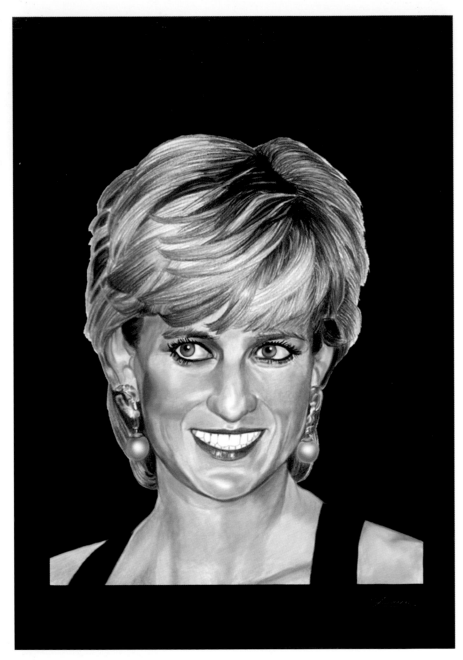

PETER MARKWORDT-DUERES

 Diana Portrait

 mixed media

 32 x 45 cm

Diana is the only one who has it worse than me with the press and paparazzi. I'd like to invite her to come and stay with me here in my New York apartment.

Madonna

Diana was an icon, an international symbol the likes of which you get maybe three or four times a century. She lived her life in such a public way. And she sold. Like Madonna sells. These women are unique in their own ways, through circumstance and talent and drive, and people either love them or hate them but either way they're fascinated by them.

Graydon Carter
Editor, Vanity Fair

SUE VICTOR

The Princess and the Diva
acrylic on stretched canvas
76 x 101.5 cm

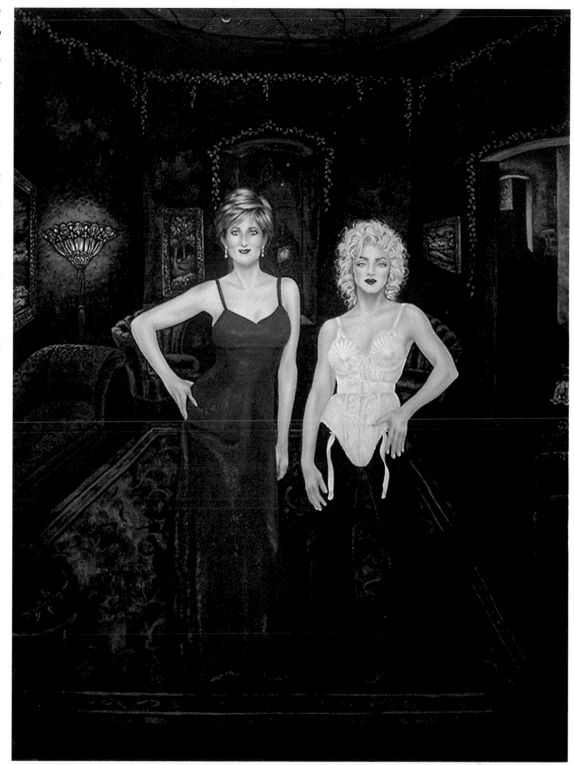

Princess Diana sought to create a new public identity after her divorce from Charles was finalised on August 28, 1996. Stripped of the prestigious title 'Her Royal Highness', Diana nevertheless won a following as what The Washington Post described as 'a benevolent alternative monarch'.

CNN

ANDONG WANG

Eternal Smiling

oil on canvas

51 x 61 cm

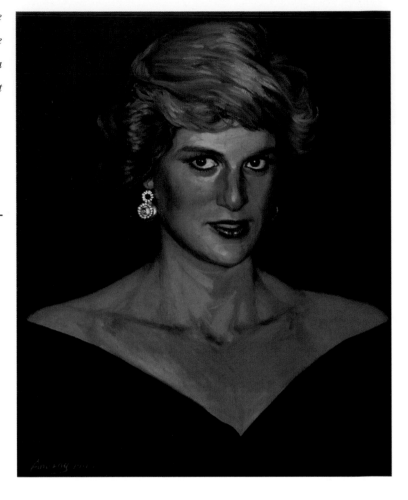

Diana's impact on the British monarchy has been catalytic and cataclysmic. In the 16 years in which she belonged to it, she changed the House of Windsor beyond recognition.

Sarah Bradford

Author

ISRAEL ZOHAR

HRH The Princess of Wales (1961–97), *(opposite)*

oil on canvas

96.5 x 76.2 cm

©Private Collection/Roy Miles Fine Paintings/The Bridgeman Art Library

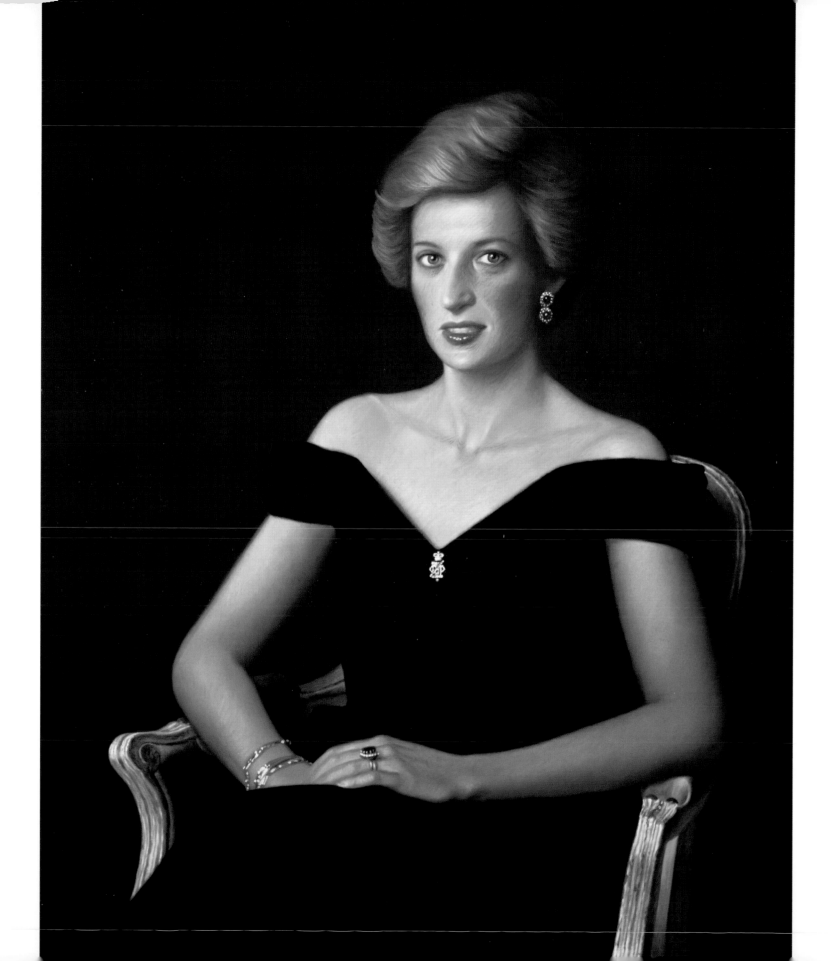

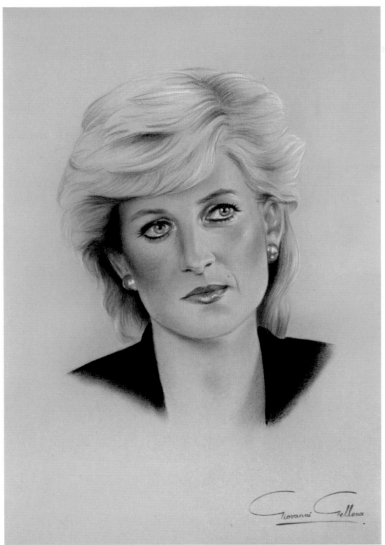

She had every right to do the Panorama interview, and I thought it was very impressive. I've no doubt in my mind that she was in love with him. It must have been a shattering blow to find that he was never in love with her. He loved another woman. What a terrible thing to do. To marry someone when you love another woman. I'm not saying I lack sympathy for him, or whoever forced him into this loveless marriage, but it's not Diana's fault.

Lord Jeffrey Archer
Author

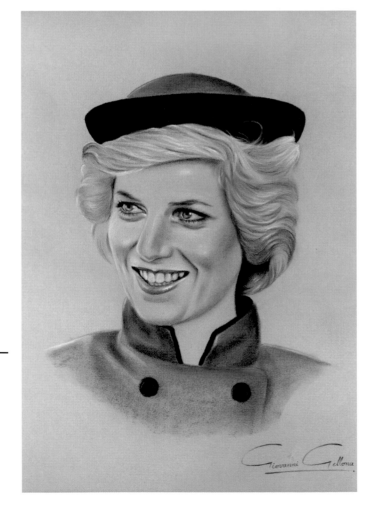

GIOVANNI GELLONA

Sad Interview (above)

pastel and pencil on paper

50 x 32 cm

Fresh Forever (right)

pastel and pencil on paper

50 x 32 cm

She appeared in off-the-shoulder black silk crepe. And she looked spectacular. She pulled out a choker of pearls, which bore a large oval sapphire surrounded by two rows of diamonds. I watched the television bulletins later that night showing her arrival on that balmy summer's night: striding enthusiastically out of the car and smiling as if she didn't have a care in the world. It became one of the most famous images of the princess and was captured on all the front pages the next morning.

Paul Burrell
Butler and friend

DIEDRE BURKE

Diana in Black

oil on canvas paper

20 x 25.5 cm

The most daunting aspect was the media attention, because my husband and I were told when we got engaged that the media would go quietly, and it didn't. And then when we got married they said it would go quietly, and it didn't. And then it started to focus on me, and I seemed to be on the front of a newspaper every single day, which is an isolating experience, and the higher the media put you, place you, is the bigger the drop. And I was very aware of that.

Diana

You'd have Princess Diana in a newsagent's, Princess Diana in a restaurant, Princess Diana parking her car, it was snowballing all the time. The prices of the pictures were going through the roof. So suddenly sitting on Princess Diana's tail for 24 hours a day, seven days a week, became very worth it.

Mark Saunders
Photographer

You don't know what it's like being chased by them. It is harassment under the guise of, you know, 'We are the press, we are entitled', and when people are having a private moment, they should be allowed to have a private moment.

Tom Cruise

HEIDI BENZ

Lasting Light
pencil and ink on paper
40.5 x 30.5 cm

When I have my public duties, I understand that when I get out the car I'm being photographed, but actually it's now when I go out of my door, my front door, I'm being photographed. I never know where a lens is going to be. A normal day would be followed by four cars; a normal day would come back to my car and find six freelance photographers jumping around me. They've decided that I'm still a product, after 15, 16 years, that sells well, and they all shout at me, telling me that: 'Oh, come on, Di, look up.' And, you know, you can laugh it off. But you get that the whole time. It's quite difficult.

Diana

Diana's death was a tragic waste of a life, and the way that it happened was so awful, and an interesting poetic way to die, certainly in her case. When you saw she was so hounded by the press and seemingly so unequipped to deal with it, it does seem like they killed her, obviously that's not exactly what happened. I was devastated, like everyone.

Madonna

JASON LEBLOND

Deer Diana

mixed media on board

46 x 61 cm

Diana kissing Dodi ... a million pounds. I think it earned in total three million pounds around the world. We were the first daily to get it. We paid a sensational amount of money for it. Most I've ever been involved in. In fact it's ten times anything I've ever been involved in and I was there at The Sun for nearly seven years.

Ken Lennox
Photographer

Sometimes the smallest gestures said more than all the gifts that they exchanged. They were always giving each other lovers' gifts – beautiful framed photos of one another, a gorgeous ring for her, cufflinks for him. You could see it in the way they would relax in the sun or swimming in the sea. The way they clung to each other in the water, and the way they only had eyes for each other.

Rene Delorm
Former butler to Dodi

DR T. F. CHEN

Embracing Vacation
acrylic on canvas
101.5 x 76 cm

The affection in which Princess Diana is still held is remarkable, but I knew Dodi and, far from being the playboy he was portrayed as, he was a charming, hard-working film producer who had made his own way in life.

Bill Mitchell
Actor

She was blissfully, ecstatically happy, having really one of the best times in her life, and Dodi was very much a part of that.

Raine Spencer
Stepmother

The world has lost a princess who is simply irreplaceable.

Mohamed Al Fayed

TARANTOLA

Dodi and Diana

oil on canvas

76 x 101.5 cm

I felt compelled to perform. Well, when I say perform, I was compelled to go out and do my engagements and not let people down and support them and love them. And, in a way, by being out in public, they supported me although they weren't aware just how much healing they were giving me, and it carried me through.

Diana

That she was, at one level, an amazing star, an amazing celebrity, and yet she was somebody with whom lots of people, who were watching what the Prime Minister said on the occasion, felt they had a personal connection, because they'd once shaken her hand, or they'd once been in a crowd and given her a flower.

Margaret Jay
Former Head of the National AIDS Trust

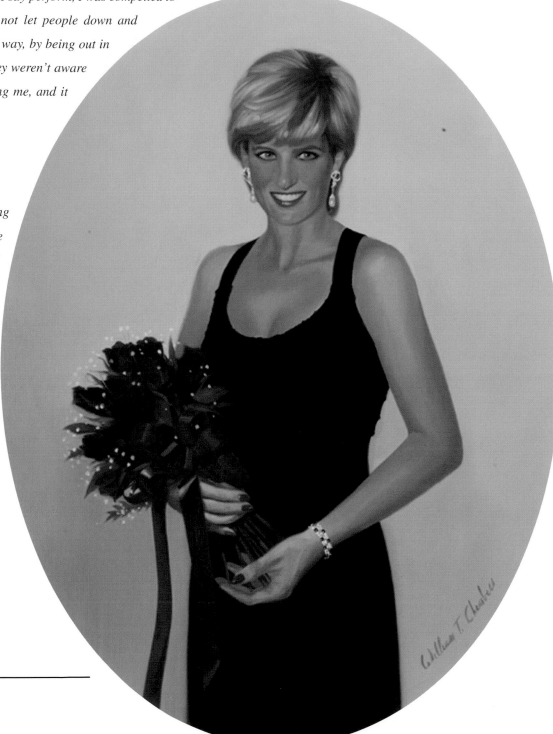

WILLIAM T. CHAMBERS

Our Beloved Princess

oil on canvas oval

61 x 76 cm

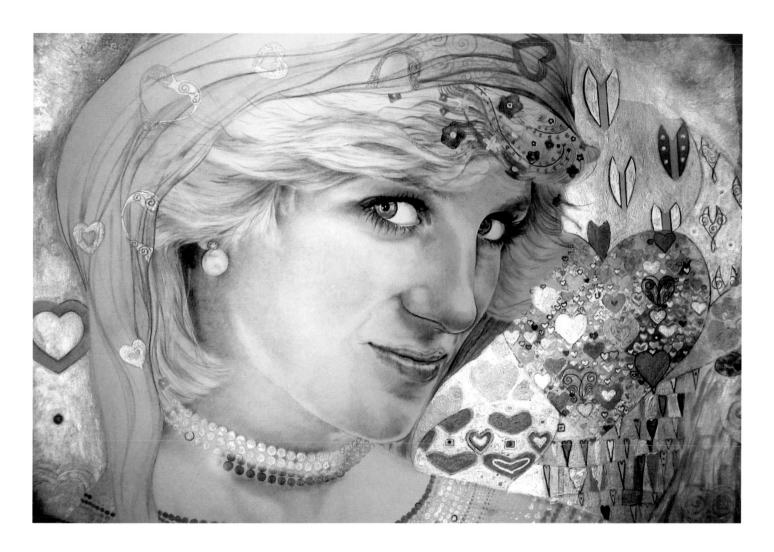

How difficult things were for her from time to time, I'm sure we can only guess at. But people everywhere, not just in Britain, kept faith with Princess Diana. They liked her, loved her, they regarded her as one of the people. She was the People's Princess and that is how she will stay, how she will remain in our hearts and our memories forever.

British Prime Minister Tony Blair

HEIDI BENZ

Global Princess

acrylic, pencil, ink on card and paper

41 x 29 cm

She is prone to depression, a woman who is easily defeated and dominated by those with a strong character. Diana has a self-destructive side. At any moment she could say 'to hell with the lot of you' and go off. The potential is there. She is a flower waiting to bud.

Felix Lyle
Astrologer

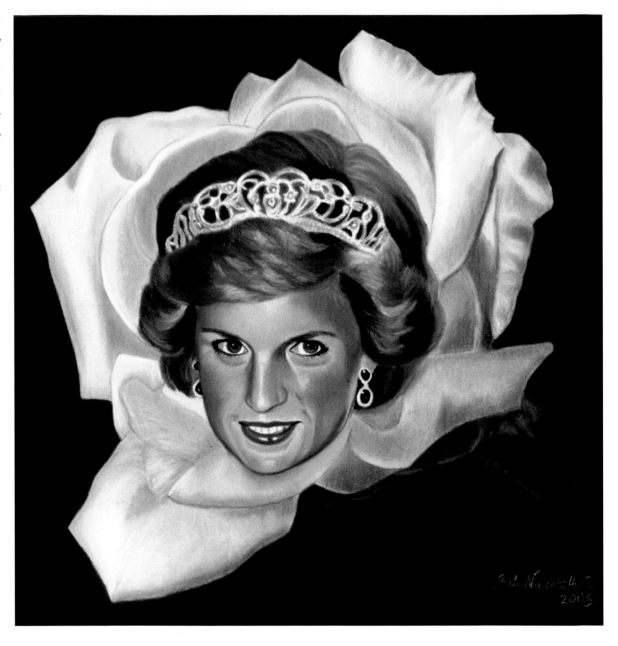

SITI NURIATI HUSIN

Princess Diana – England's Rose

pastel on Canson paper

49.5 x 51 cm

This past week has been like no other I have ever known, simply because I can't remember the British public sharing their grief quite so openly. Day by day, we all tried to find a way of dealing with the loss. Some queued for hours to sign books of condolence, others went to Buckingham Palace to reflect. This year, Diana had a white rose named after her. I shall plant one and give it a bucket of the enrichment that she and I once shared. I think that would make her smile.

Alan Titchmarsh
TV presenter

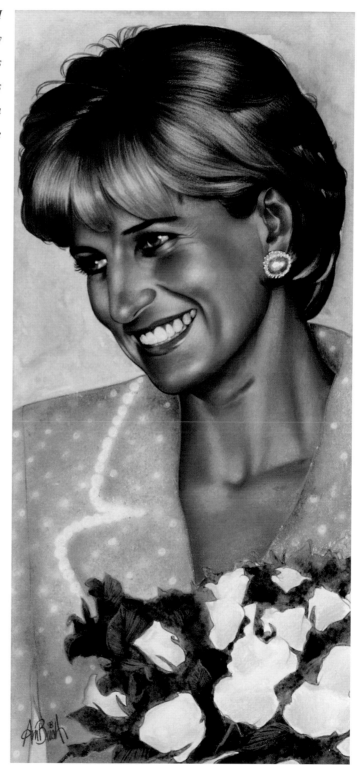

PETER AMBUSH

Princess Diana – Star Ledger TV guide cover

colour pencil, acrylic on watercolour paper

16.5 x 35 cm

Not since the death of President John F. Kennedy 34 years ago has America mourned in the way it did yesterday. The national reaction to Diana's funeral was far deeper and expressed with greater emotion than it was for the death of Jackie Onassis, Grace Kelly or even Elvis.

William Lowther
Journalist

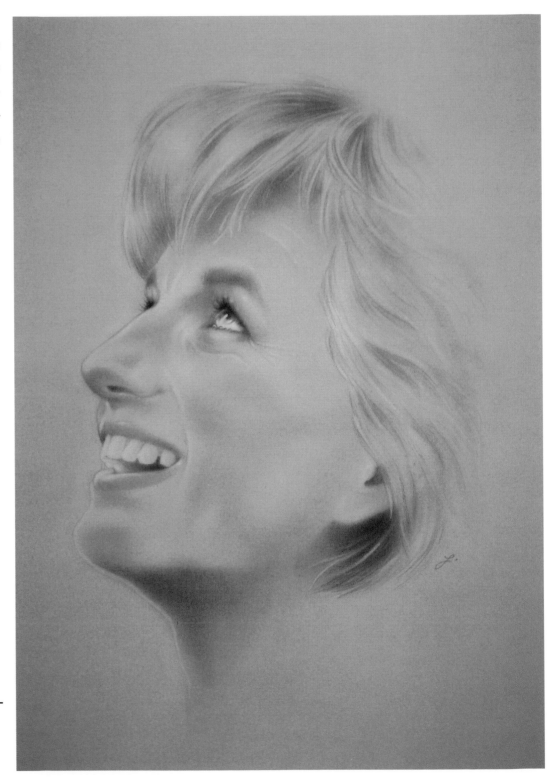

JOHNATHAN-PETER BARNETT

Diana

soft pastel on canvas

76.2 x 51 cm

The untimely demise of a young woman at the peak of her beauty and powers, of a mother whose two young sons still very much needed her love and guidance, is always a tragedy. The fact that this young woman was a Princess who once was in line to become Queen of the world's most visible monarchy and, even after losing that status, remained a global icon in her own right, compounds that tragedy many times. She was the most recognisable figure on the planet.

Anna Pukas
Daily Express

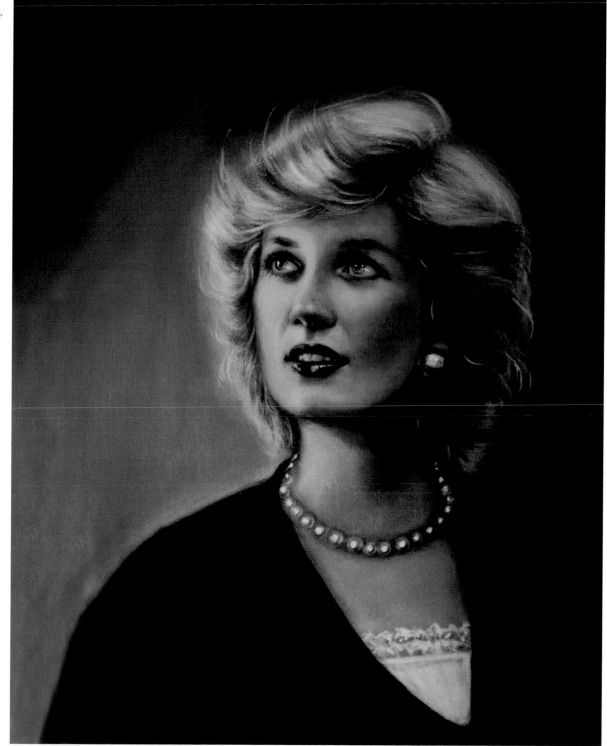

ANDREA SALTZMAN

Eternal Diana

oil on canvas

76 x 66 cm

The press is ferocious. Whatever I do, wherever I go it waits for me, it tracks me down whatever I do, whatever I say it will always look for controversy and contradiction. It will always criticise me.

Diana

GIOVANNI GELLONA

Cool Cruelty

pencil on paper

50 x 32 cm

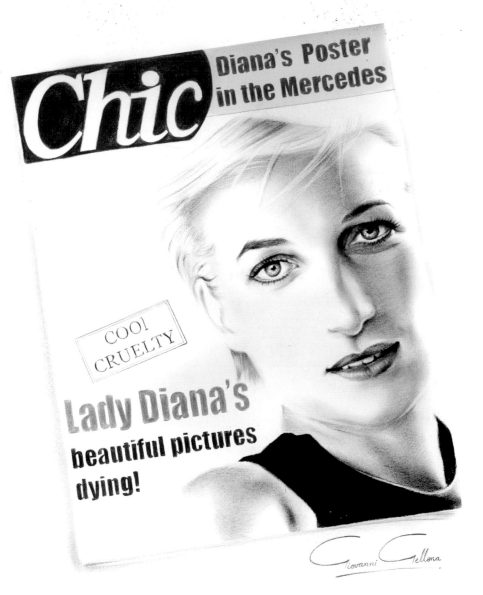

Lady Di launched at least a thousand covers, and hundreds of millions of newspaper and magazine sales. In the 16 years since her marriage she became not only the most famous woman in the world, but the only personality who consistently sold big in the global marketplace. While paparazzi are not a new phenomenon, Diana-as-prey took the game to a new level. Instead of three or four photographers trailing a celebrity, it could, in her case, be 30 or 40, each hoping for that six-figure shot.

Jonathan Alter

Newsweek

KEN KEELEY

Cover Stories, 1997 News Stand (opposite)

oil over acrylic on linen canvas

122 x 152.5 cm

There are plangent similarities between the two 20th century goddesses. Authur Miller wrote of Marilyn Monroe that no one had such a gift for life as she did, that she could come into a room and light it up, that her vitality transformed others. The same could be said of the late Princess, who so longed for the reciprocated warmth of others.

Nigella Lawson
TV presenter

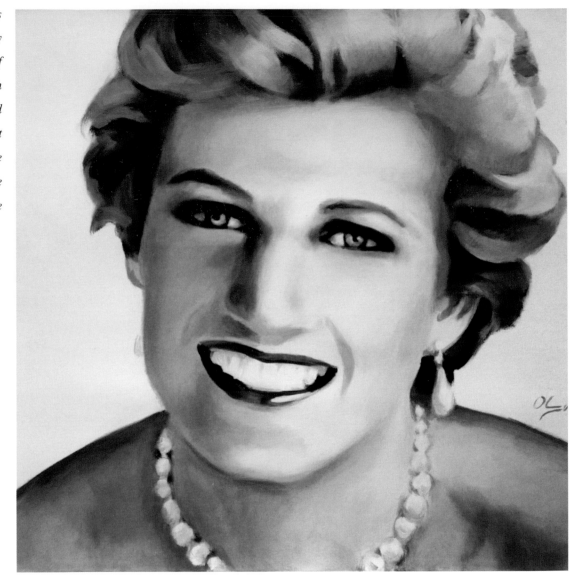

OLEG DYCK

Portrait of Princess Diana

acrylic on canvas

71 x 71 cm

For 15 years we have lived with her every day of our lives. But, as with Monroe, or Dean, or Evita, it took her death to make us realise what she was doing there.

Jim White
Journalist

Diana's afterlife is only just starting. Forever frozen at the height of her beauty, Diana, like Marilyn Monroe, that other troubled goddess, will not die.

Suzanne Moore
Columnist.

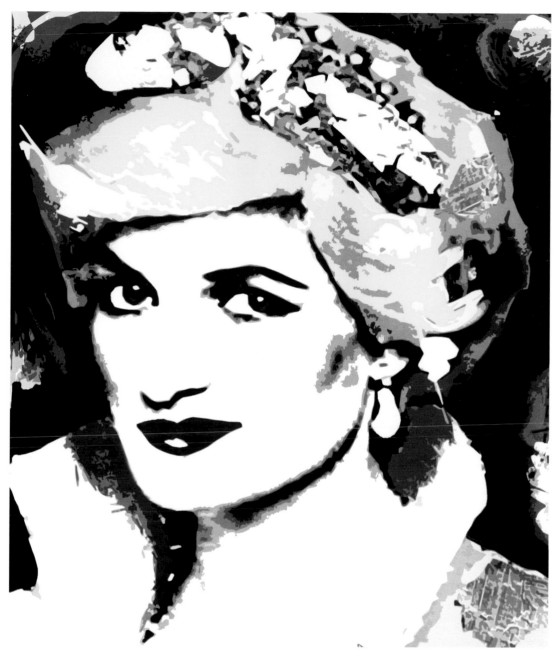

LUCIANA CAPORASO

My Diana

acrylic, silver and gold leaf collage

101.5 x 76 cm

What the establishment wanted more than anything else while Diana was alive, was for her to be back in her box. The great horror for them when she died was that she was out of the box again. Her memory, her face, were everywhere. Since her death there has been an absolute concerted attempt to try and get her back in that box, to try and stop her memory lingering on.

Vivienne Parry
Friend

Down in the engine room of the culture she had, without anybody being fully aware of the fact, Diana attained some sort of ultimate celebrity. She had become, as everybody keeps saying, 'an icon', like Elvis, Marilyn Monroe, Evita. But there is more to it than that. Diana died instantly and everywhere – on the Internet, CNN and every TV screen in the world, on the radio, in every newspaper. She was the first icon to fully live and die in the global village. As such she has become, arguably, the greatest celebrity ever.

Michael Joseph
Author

GEORGE PUSENKOFF

> **Diana, Snapshot 1997** *(above)*
> *acrylic on canvas*
> *270 x 270 cm*
> **Untitled Di 1997** *(right)*
> *acrylic on canvas*
> *200 x 200 cm*

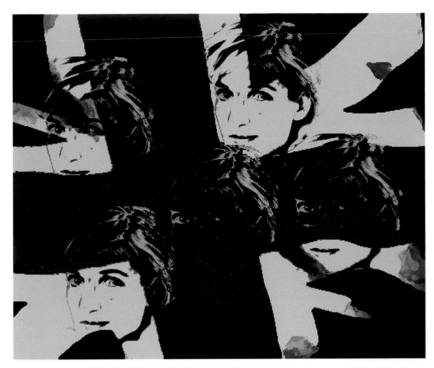

I felt really sad one particular evening when I went to photograph her at the President's banquet. She arrived and she'd obviously been crying. Her eyes were red, she'd put a lot of make-up on her face to cover up her bags and her red, sore eyes. She stood there shaking all these hands and then went and sat at the banquet table and this large Union Jack was hanging on the wall behind her, which was very poignant really. She sat there with all her finery on and her tiara and she just stared at the tablecloth.

Jayne Fincher
Photographer

From punk rocker to Chelsea Pensioner they came, joining the vast crowds gathering to pay grief-stricken tribute. Many were in tears. In mid-afternoon a punk rocker complete with a Mohican haircut and a Sex Pistols T-shirt laid a large bouquet spelling 'Diana'. Too upset to comment, he simply bowed his head and walked away.

Daily Mail

BOREA DOMENICO

 Union of the Lady and the Princess (above)

 graphics

 46 x 25.5 cm

 Rocker Diana (right)

 digital painting

 51 x 25.4 cm

If any single memory persists after this week of grief, it is a vision of the beautiful Diana gazing at Patrick Demarchelier's lens, her eyes dancing, her comfortable smile at one with the camera.

Mimi Spencer
Journalist

I thought Diana was fantastic. She was very open. She talked to everybody. She was very sweet. But what I loved about her was her smile. She has an amazing smile. When she smiled, it was like the whole world lit up. It was a very sexy smile, beautiful.

Patrick Demarchelier
Photographer

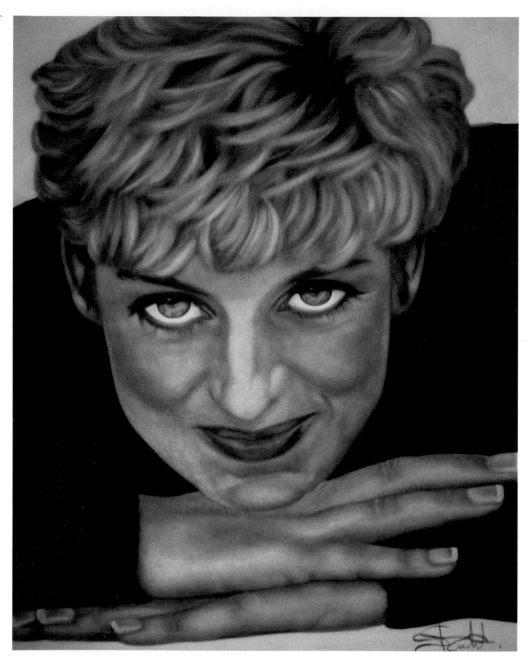

VICTORIA STAMBOLIS

> **Forever Beautiful**
>
> *oil on canvas*
>
> *183 x 122 cm*

First Demure Di, then Disco Di, next Dynasty Di, now Dedicated Di. Some people are even beginning to talk about her as a saint.

Vanity Fair

ORLENA ONSTOTT

Portrait of a Legend *(above left)*

Fashion Icon *(above right)*

Diana in the Spotlight *(below left)*

Majestic Diana *(below right)*

all are pastel chalk on paper

all are 21.5 x 28 cm

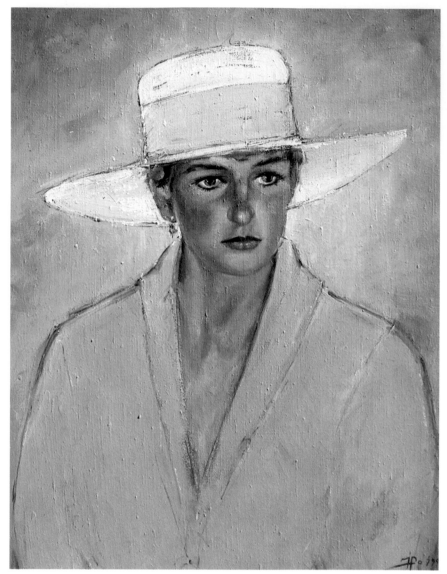

Perhaps no image, moving or still, said more about her – her bravery, her restlessness, her sorrow – than those television reports on the night of August 31st, which showed the queen of all our hearts and souls coming home at last, to RAF Northolt like the good soldier that she was. Her death has preserved her forever at the height of her beauty, compassion and power.

Julie Burchill
Author

IOAN POPEI

Diana

oil on canvas

63 x 79 cm

Sources of strength from within the Princess's inner circle were around me. Her friends, the people who knew her best, were rallying round as a team, ensuring that the farewell went perfectly. Susie Kassem came to the palace. She brought with her a candle. Together we went to the stairs, a landing point on one of the turns. We stopped beneath the huge Nelson Shanks portrait of the Princess. Susie bent down and placed the lit candle on the carpet. We knelt together and prayed, sharing our own memories in silence.

Paul Burrell
Butler and friend

NELSON SHANKS

Portrait of HRH Diana, Princess of Wales (opposite)

oil on canvas

162.5 x 101.5 cm

Collection of Charles, Ninth Earl of Spencer, Althorp, Northamptonshire, England

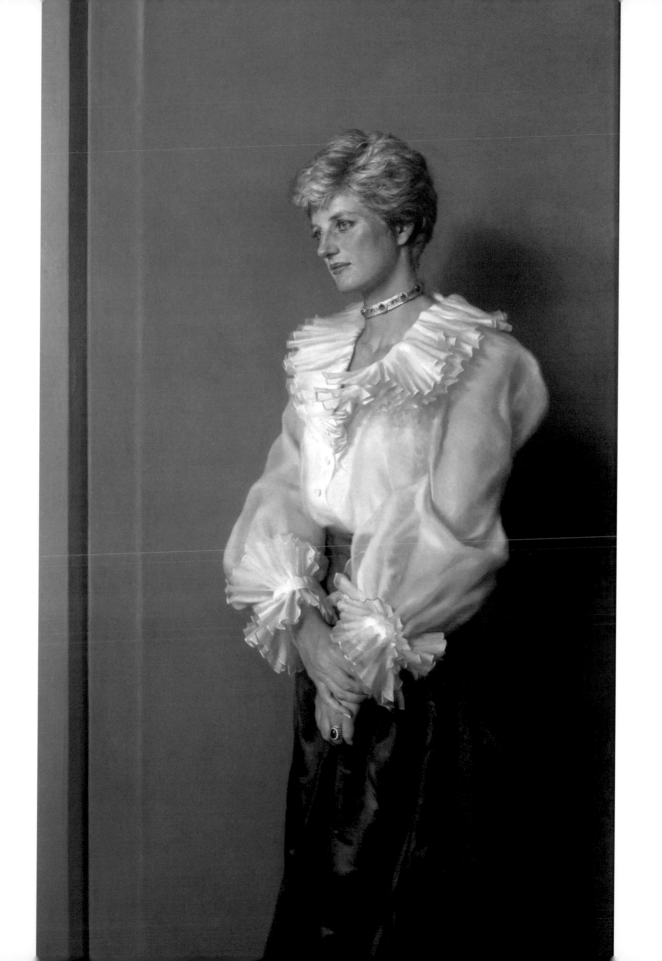

Princess Diana was well known and loved by the people of Russia. Everybody knew about her huge contribution to charity, both in Britain and outside. Many exceptional projects that touched the lives of ordinary people have been put into practice in Russia with her direct participation.

Boris Yeltsin
Former Russian President

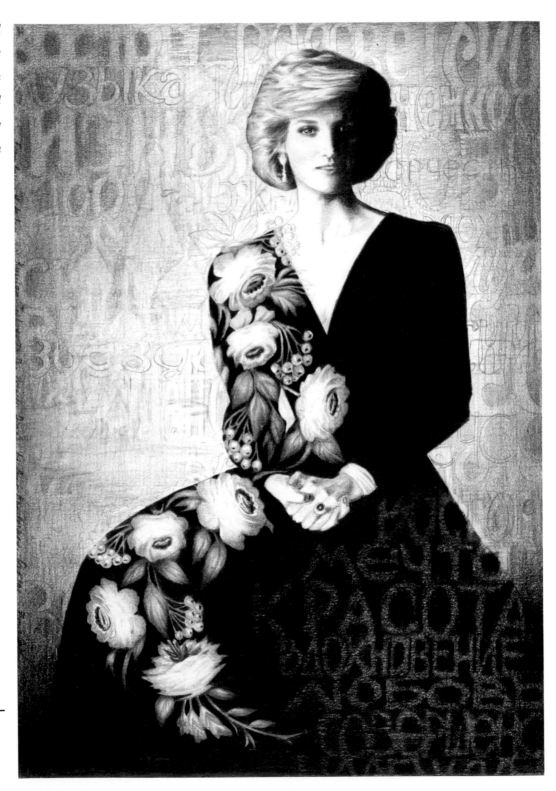

BAUR BERDESHEV

Russian Tribute to Diana

pencil on paper

40.5 x 51 cm

No-one who knew Diana will ever forget her. Millions of others who never met her, but felt they knew her, will remember her. I for one believe there are lessons to be drawn from her life and from the extraordinary and moving reaction to her death. I share in your determination to cherish her memory.

HRH Queen Elizabeth II

SHAWN LUKINS

Princess Diana

airbrush, pencil, Exacto knife, eraser on art board

41 x 51 cm

The modern mega-celebrity, bearing the burden of collective symbolism, projection and fantasy, is a ritual victim, cannibalised by our pity and fear. Those at the apex of the social pyramid are untouchables, condemned to horrifying solitude. Diana the huntress is now the hind paralysed in the world's gunsight.

Camille Paglia
Author

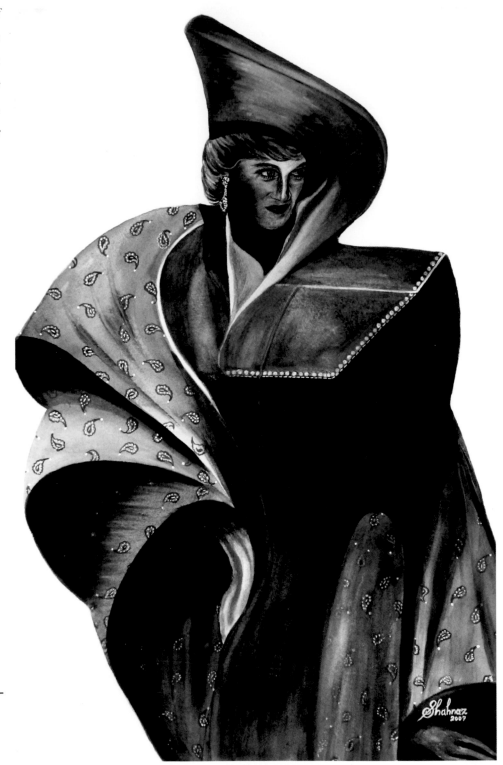

SHAHNAZ

White Pearls

watercolour on Arches cold paper

56 x 43 cm

I do not blame her death on the press, but I do blame the fact that she was very lonely and very neglected beforehand.

Dame Barbara Cartland
Novelist and step-grandmother

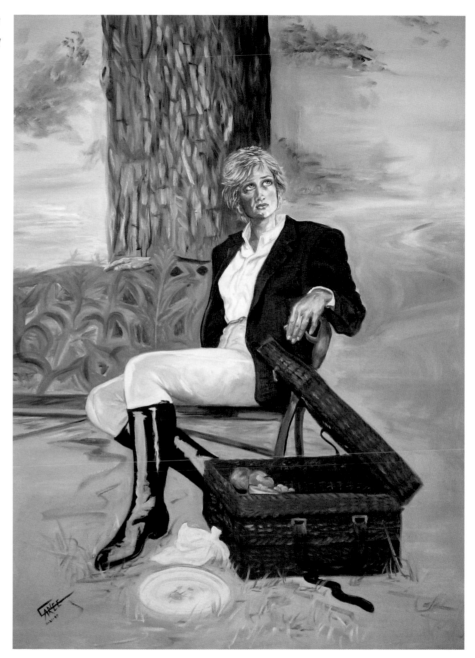

CARLEE MILLER

Diana Post Charles
oil on canvas
76 x 101.5 cm

From the word go, I felt as if I was a friend of hers and even though official formalities were inevitably present, her down-to-earth manner was most impressive. I think this kindness she showed as a person extended into her charity work and I believe that everybody who met her was touched by this special feeling.

Sir Paul McCartney

ED CHAPMAN

Diana

ceramic mosaic on board

91 x 62 cm

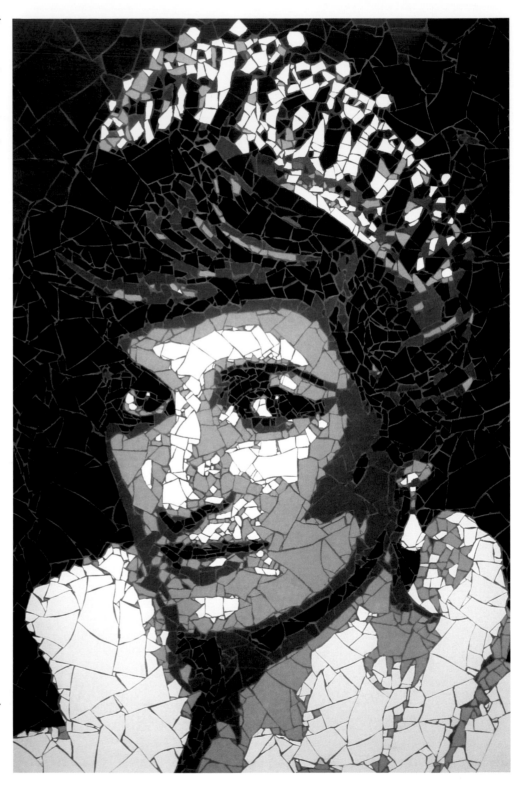

Eva Peron still symbolises hope in Argentina, in a way no politician, no royal, no film star, has managed anywhere in the world before or since. Until Diana. I remember so well how the Princess once said that she wanted to be queen of people's hearts. I wonder if she knew that she was echoing Eva Peron's remark: 'I want to be queen in your heart'? Few, apart from Diana, have come anywhere near Eva Peron's ability to make people feel she really cared about them.

Nicholas Fraser
Author

Princess Diana managed to make her way to the heart of my people. Exceptional, absolutely positive.

Carlos Menem
Former Argentinean President

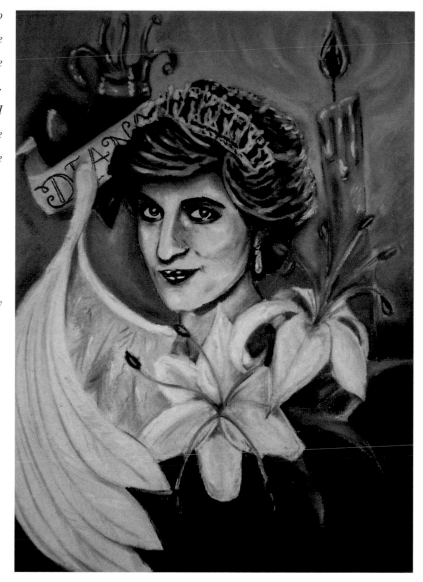

TARREN MALHAM

Princess of the People

soft pastel on paper

40.5 x 30.5 cm

The death in such tragic circumstances ... has ended, at a young age, the life of a person who held a particular fascination for many people around the world.

John Howard
Australian Prime Minister

NOEL CRUZ

Princess of Style

graphite pencil on charcoal paper

30.5 x 21.5 cm

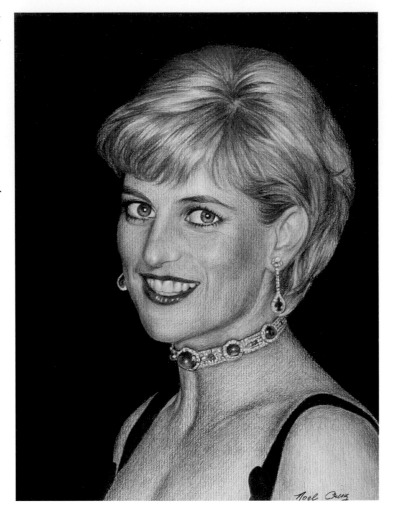

In Japan too, she was adored. I have travelled and seen many people who are important and great campaigners. However, she was when I met her absolutely beyond my imagination, charming to the ultimate. I don't think there will be anybody in this 21st century that will come equal or close to her level of charisma.

Tokuo Kassai
Chairman of fundraising committee, Japan.

DAVID KETTLEY

Diana Tretchikoff *(opposite)*

acrylic on canvas

61 x 53 cm

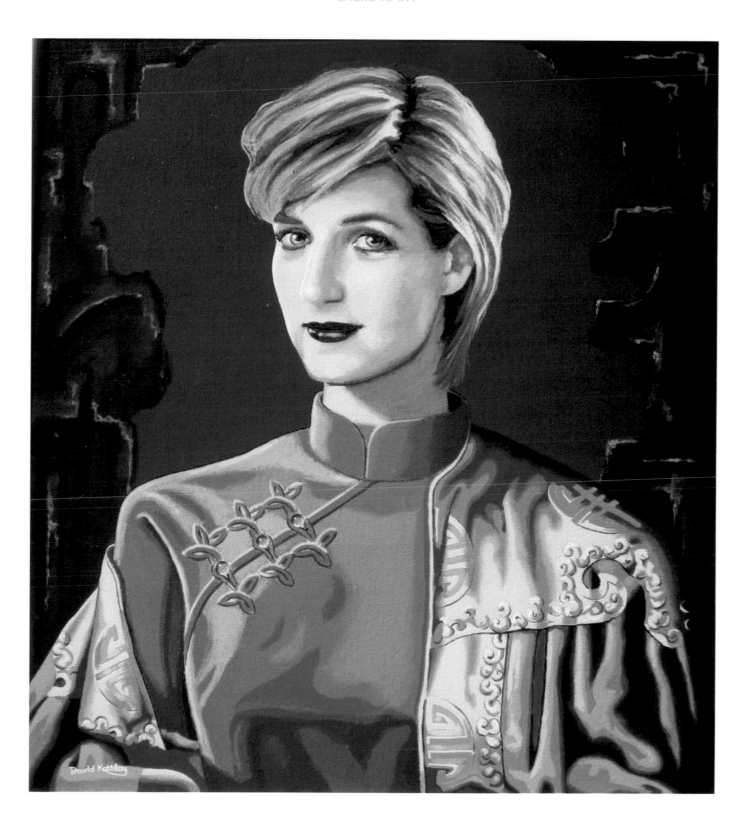

A mother with HIV or AIDS doesn't give up the responsibility of caring for her children easily. Often she is the sole parent, the wage earner, the provider of food, the organiser of daily life, the nurse to other sick members of the family, including her own children. As well as the physical drain on her energy, a mother with HIV carries the grief and guilt that she probably won't see her healthy children through to independence.

Diana

She had more guts than anyone else. I want to carry on the things she didn't quite finish. I've always wanted to – but before I was too young. She got close to people and went for the sort of charities and organisations that everybody else was scared to go near, such as landmines.

Prince Harry

Princess Diana had indeed become an ambassador for victims of landmines, war orphans, the sick and needy throughout the world.

Nelson Mandela

MEHMET MEHMET

Your Inspiration – A Woman of Letters

gouache on canvas

40.5 x 51 cm

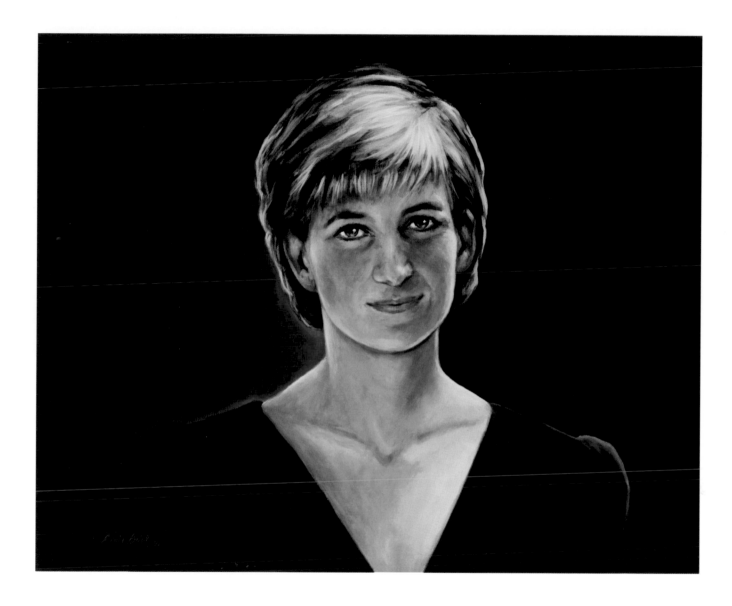

Diana was a personal friend and someone I greatly admired for her tireless and enthusiastic work for charity.

Elton John

LOUIS BRIEL

Diana 1997 – Collection of Elton John

acrylic on canvas

56 x 71 cm

The scenes outside Kensington Palace that Sunday were extraordinary. So many people from all ages, classes, colours and creeds – mourning Diana, Princess of Wales in stunned grief, carrying flowers of every kind, from tiny garden posies to luxuriant white lilies. Each offering carried a message of devotion and love: 'To Diana, our true Queen of Hearts', 'To Diana, the people's Queen', 'To Diana, we will never forget you', 'To Diana, who was too good for this world, and so returned to God'.

Mary Kenny
Journalist

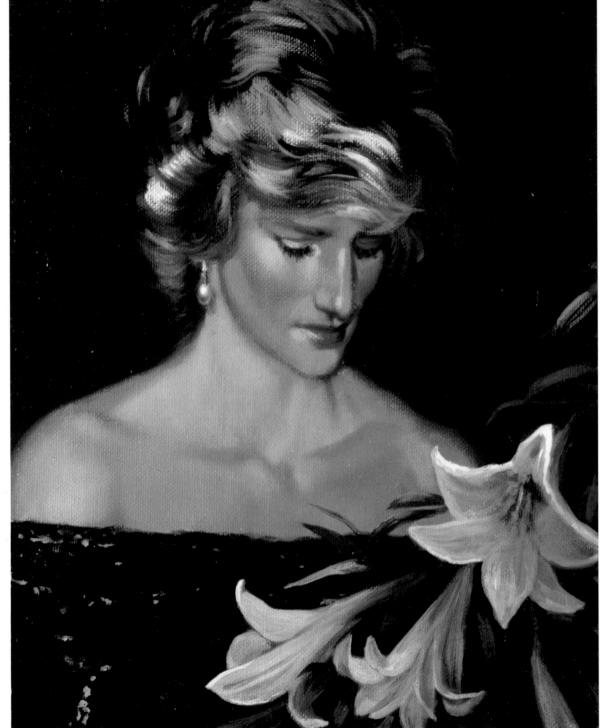

ANDRE DURAND

Diana, 1997

oil on canvas

©www.durand-gallery.com

The Bridgeman Art Library

If you went down to Kensington Palace to pay your respects, there were old people there and royal fans. But there were other faces too: Asians, black Britons, there were hip young things. And there were gay people, lots of them, wanting to show they cared. The first people to turn up with flowers at Di's place came straight from the nightclubs. There is no one else in Britain you could imagine them turning out for. Except Diana.

Jim White
Journalist

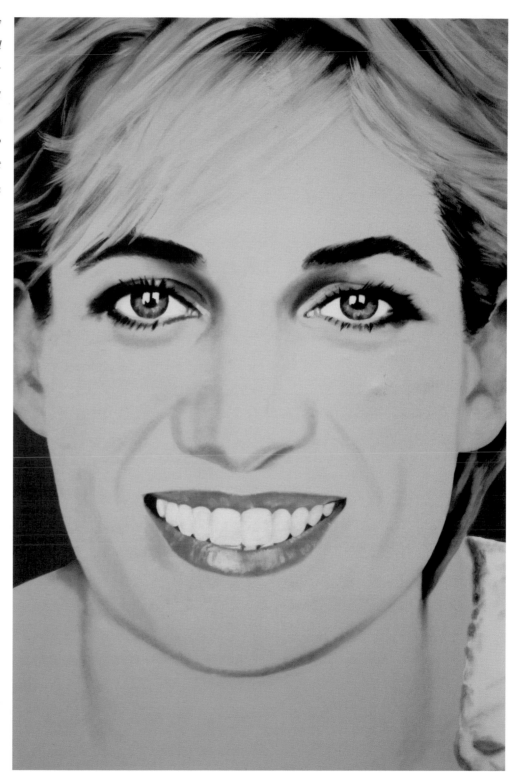

TRADEMARK

The Princess of Wales
acrylic on canvas
183 x 122 cm

Those Whom The Gods Love Die Young.
The tragic death of Diana, Princess of
Wales, at the height of her beauty and
celebrity, has ensured her a permanent
place in the pantheon of world stardom.

Sarah Bradford
Author

BAUR BERDESHEV

Lady Diana

pencil on paper

40.5 x 51 cm

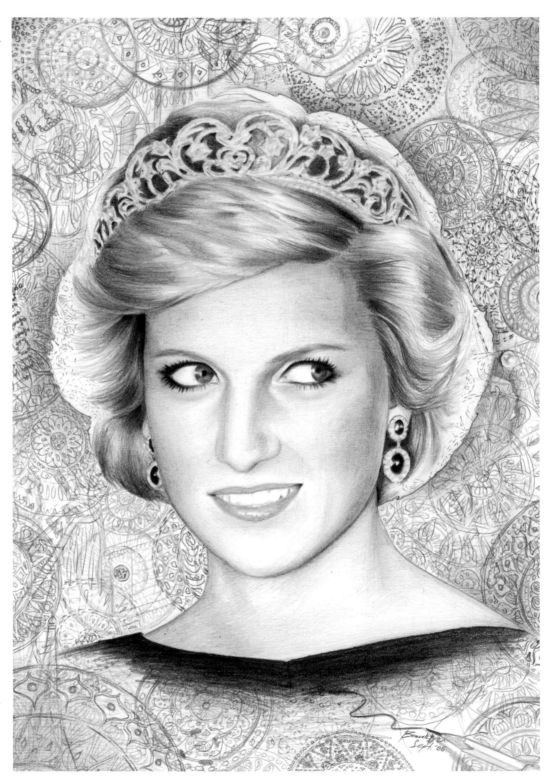

The enormous outpouring of grief and support in the wake of Diana's death demonstrates that people saw in her more than her radiant beauty, but instead a different kind of royalty.

Former US President Bill Clinton

She did hard work in difficult places and she softened hearts and lifted spirits. Today the shadows are longer because we have lost a light that shined brightly and gently, and we will miss her.

Hillary Clinton

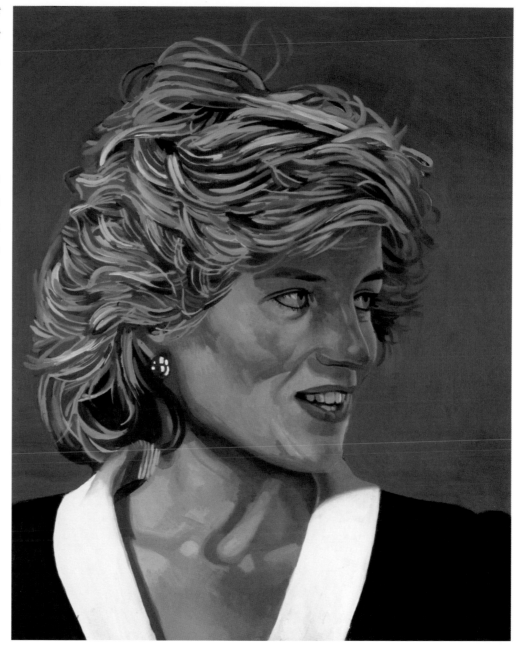

THOMAS GRIFFIN

A Study in Beauty

oil on board

39 x 31 cm

A beacon of light has been extinguished.

Baroness Margaret Thatcher

Frailty, the apparent brave frailty of a candle in the wind, was always Diana's supreme public quality in life.

John Ezard
Journalist

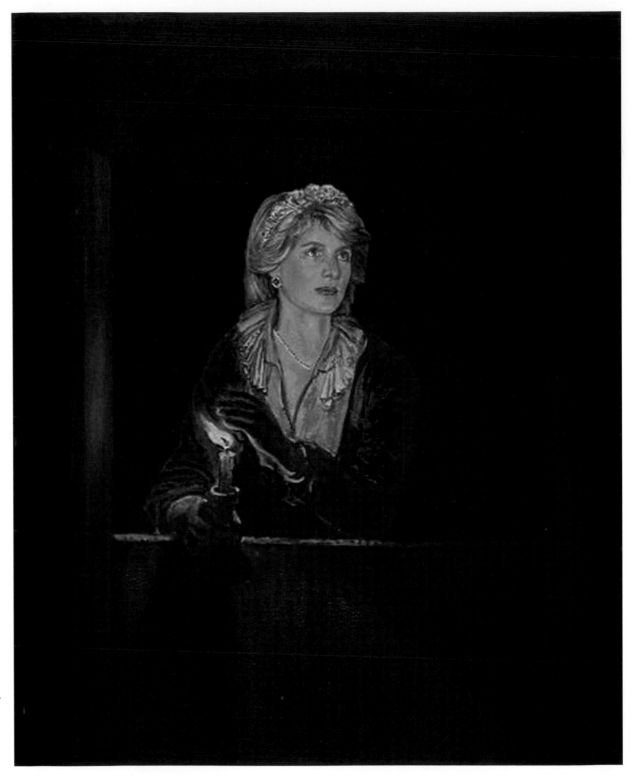

RON KEAS

Candle in the Wind

oil on canvas

40.5 x 51 cm

We admired her work for children, for people with AIDS and for the discouragement of landmines. I will always be glad I knew the Princess. All of us have lost a friend and a strong voice for those less fortunate.

Former US President
Bill Clinton

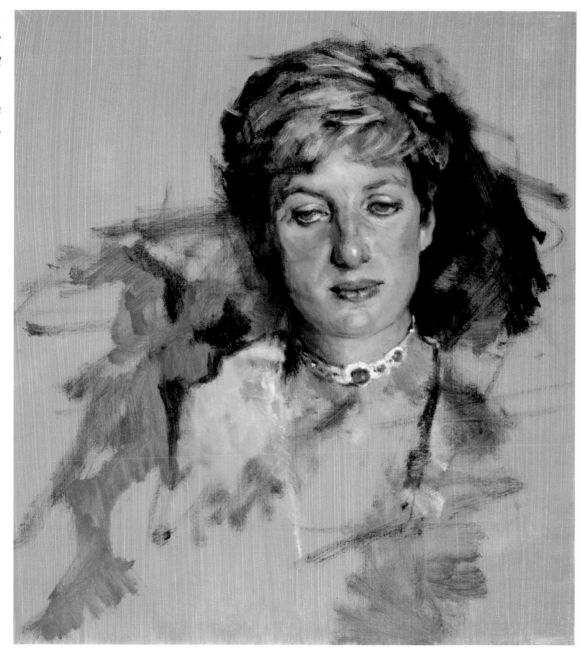

NELSON SHANKS

Diana, Princess of Wales – A Study

oil on canvas

51 x 46 cm

She paid a horrible price. There is this illusion about being famous and rich, but it is nothing more than that. It is an illusion. She showed us that, and dramatically.

Chris de Burgh
Recording artist

SIU LING MARTINEZ

Princess Di

enamel on canvas

61 x 76 cm

A charity set up in memory of Diana, Princess of Wales was relaunched today by Gordon Brown with the blessing of the House of Windsor and the Spencer family. The renamed Diana Award will operate as an independent charity for the first time and aim to raise £1 million a year to further the work of the Princess with young children.

The Daily Telegraph

The Diana Award celebrates the fantastic achievements of ordinary people who do extraordinary things. Through their activities they display the values that we should all aspire to: valour, compassion, imagination, teamwork and sacrifice. Even 10 years on from Princess Diana's tragic death her memory continues to inspire young people to devote their time and energy – as Diana did – to helping others in their communities.

Gordon Brown
UK Chancellor of the Exchequer

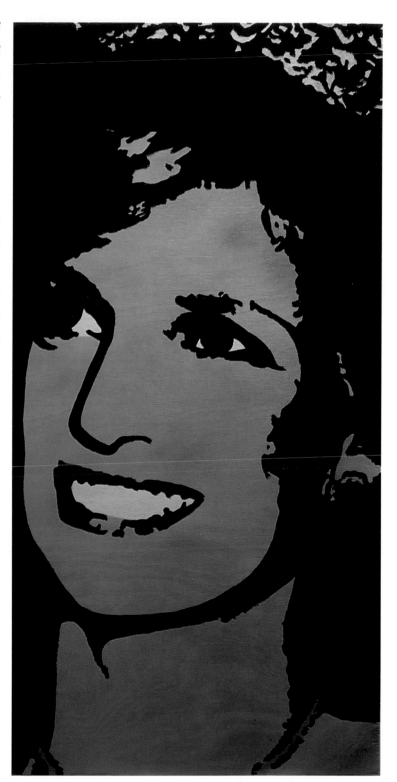

CHRIS P. JONES

Princess Diana

spray paint, acrylic on wood board

122 x 61 cm

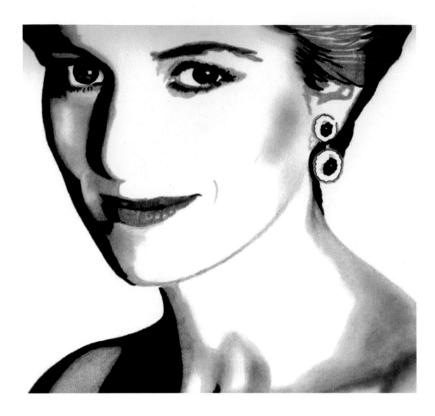

For once the celebrities took a back seat – there simply to pay a tribute to a friend. Many of Diana's favourite stars from the worlds of theatre, dance, music, films and fashion slipped into Westminster Abbey almost unnoticed. Elton John arrived with George Michael and the two walked quickly inside without pausing or speaking. Sting and his wife Trudi Styler were also there. Other pop stars included Bryan Adams, Diana Ross, Phil Collins, Brian May and Roger Taylor of Queen, Chris de Burgh and Sir Cliff Richard. Hollywood stars Tom Hanks, Tom Cruise, his wife Nicole Kidman, and producer Steven Spielberg, stood shoulder to shoulder with other mourners waiting to take their seats. Luciano Pavarotti was there with fellow tenors Placido Domingo and Jose Carreras. Donatella Versace attended just weeks after the Princess had flown to Rome for the funeral of her brother Gianni.

Michael Burke
BBC News

DAWN BIGFORD

Diana – A Portrait
graphite on paper
35.5 x 43 cm

This was the most tragic and senseless death. The world has lost one of its most compassionate humanitarians, and I have lost a special friend.

Sir Elton John

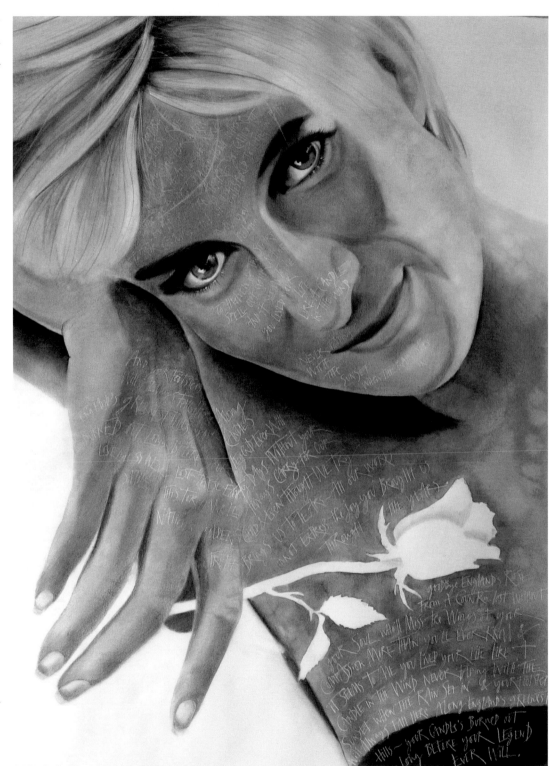

BOB HARPER

Goodbye England's Rose

watercolour, pencil, chalk on board

57 x 75 cm

I distinctly remember her caring. That is how I remember her best, and let it be that only good surrounds her in her rest.

Barry Gibb
The Bee Gees

I truly believe that some souls are too special, too beautiful, to be kept from heaven, however painful it is for the rest of us to let them go. God bless you, Diana, you will surely rest in peace.

George Michael

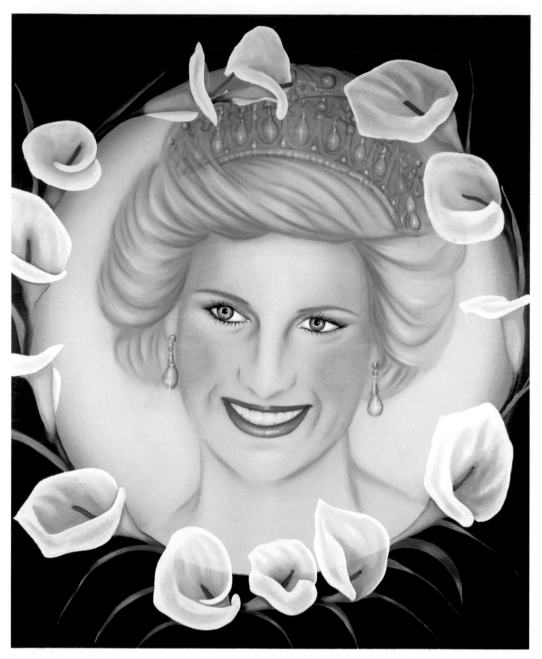

COLIEN LANGERWERF

Diana 2006

oil on canvas

120 x 100 cm

Saints are not perfect – they are flawed people who become extraordinary and who have an exceptional gift for sacrifice and reaching others through example. It would be fanciful to call Diana a saint, but she had something of the quality that saints have. And if saints continue to exercise their spiritual powers from beyond the realm of the material world, Diana will certainly do that. She cannot be replaced, but her influence will live on.

HELLO!

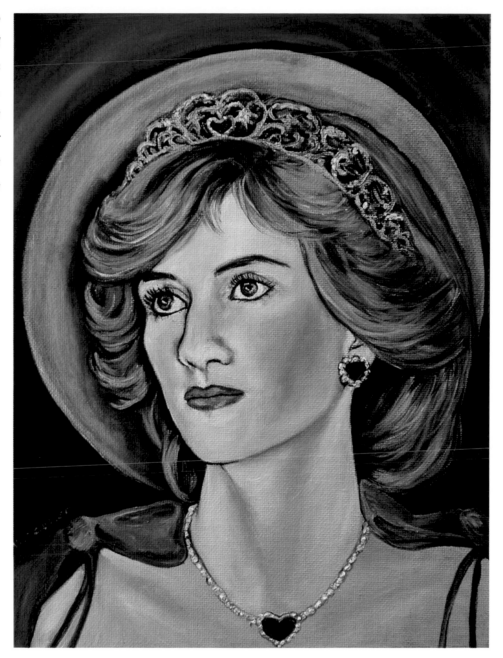

VICKY E. STADTLER

St Diana

oil on canvas

20 x 2.5 cm

Her death, according to those who responded to a poll for the History Channel, was perceived as the most significant event of the twentieth century – ahead of the beginning of the Second World War.

Andrew Morton
Author

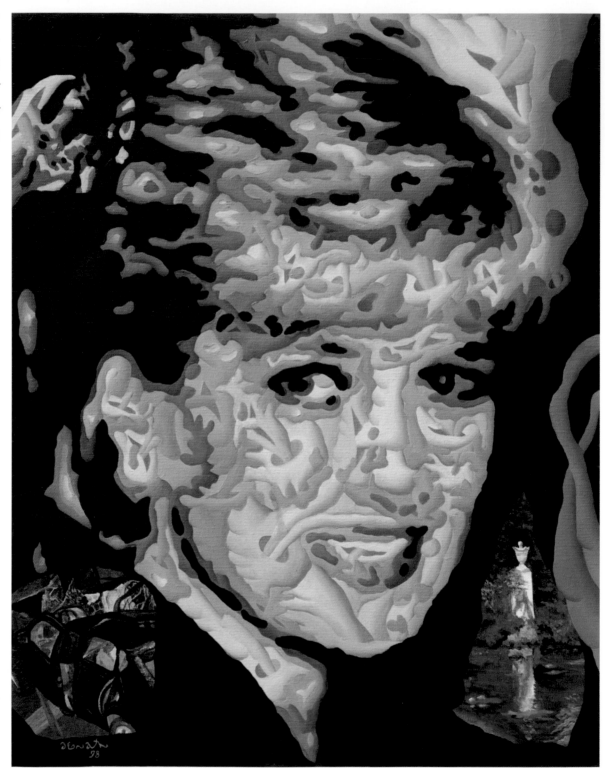

WERNER HORVATH

Diana, Princess of Wales

oil on canvas

50 x 40 cm

The Alma Bridge which spans the river Seine in Paris is a lively spot. Near its southern end, the government offices of the Quai d'Orsay jostle against the ateliers of famous couturiers. Stand on the bridge and turn to one side and you see the imposing Hotel des Invalides, last resting place of Napoleon. Turn to the other side and the Eiffel Tower – that unmistakable symbol of Paris – looms over the city. But on the north bank of the river there is a short, nondescript section of road that is now as famous as any of Paris's historic landmarks. For it is here that Diana, Princess of Wales met her tragic death, sparking the biggest mystery of our times.

Anna Pukis
Journalist

BRADY

The Thread of Life

pencil and acrylic on paper and canvas

56 x 71 cm

She touched the lives of so many others in Britain and throughout the world with joy and with comfort. How many times shall we remember her in how many ways – with the sick, the dying, with children, with the needy. With just a look or a gesture that spoke so much more than words, she would reveal to all of us the depth of her compassion and her humanity.

British Prime Minister
Tony Blair

JOHN MARTIN SAIN

Di x 5

acrylic on Bristol board

51 x 46 cm

I want to pay tribute to Diana myself. She was an exceptional and gifted human being. In good times and bad, she never lost her capacity to smile and laugh, nor to inspire others with her warmth and kindness.

HRH Queen Elizabeth II

TARANTOLA

Queen

oil on canvas

76 x 101.5 cm

Diana's funeral was attended, via television, by some 2.5 billion people around the world, getting on for a third of the world's population. In London, the route of the procession had been lengthened to accommodate the crowds, by public demand, and for fear that people might die in the crush to mourn her. Thousands slept out in the streets overnight, knowing that nothing like this would ever happen again in their lifetimes. There had been no comparable event in British history.

Anthony Holden
Author

LANA-MARIE GABRIELLE PETERSEN

Diana – Princess of the World

needle-brush painting

70 x 100 cm

Princess Diana once memorably said that she wanted to be the queen in people's hearts. Perhaps what we are seeing in the streets of London today is the coronation of that queen.

David Dimbleby
BBC TV

The funeral today of Diana, Princess of Wales, was watched by a million people on the streets of London, and two billion more on the television sets of the world.

The Evening Standard, London

MELISSA CONNOR

 Royal Love

 oil on canvas

 46 x 61 cm

There are no words strong enough to describe the pain in my heart. The world has lost the most compassionate of humanitarians and someone so special, whose presence can never be replaced.

Sarah Ferguson
Duchess of York

ROB SURETTE

Diana

latex acrylic on canvas

183 x 137 cm

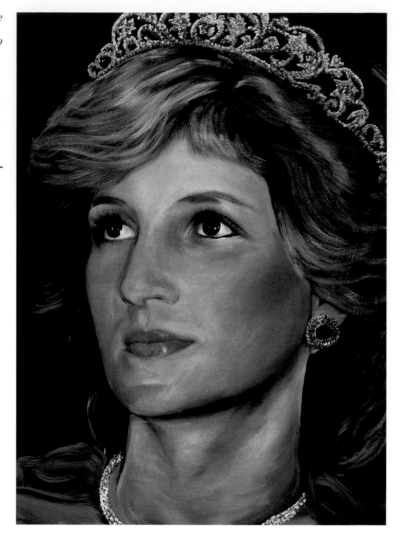

Diana lives on. She resides in the memory of friends and enemies, in the recollection of her touch by those who felt her presence as the self-appointed angel to the downtrodden.

Howard Chua-Eoan
Journalist

CHANTELLE TOKARZ

Transcendence *(opposite)*

chalk pastel with some acrylic on canvas

18 x 13 cm

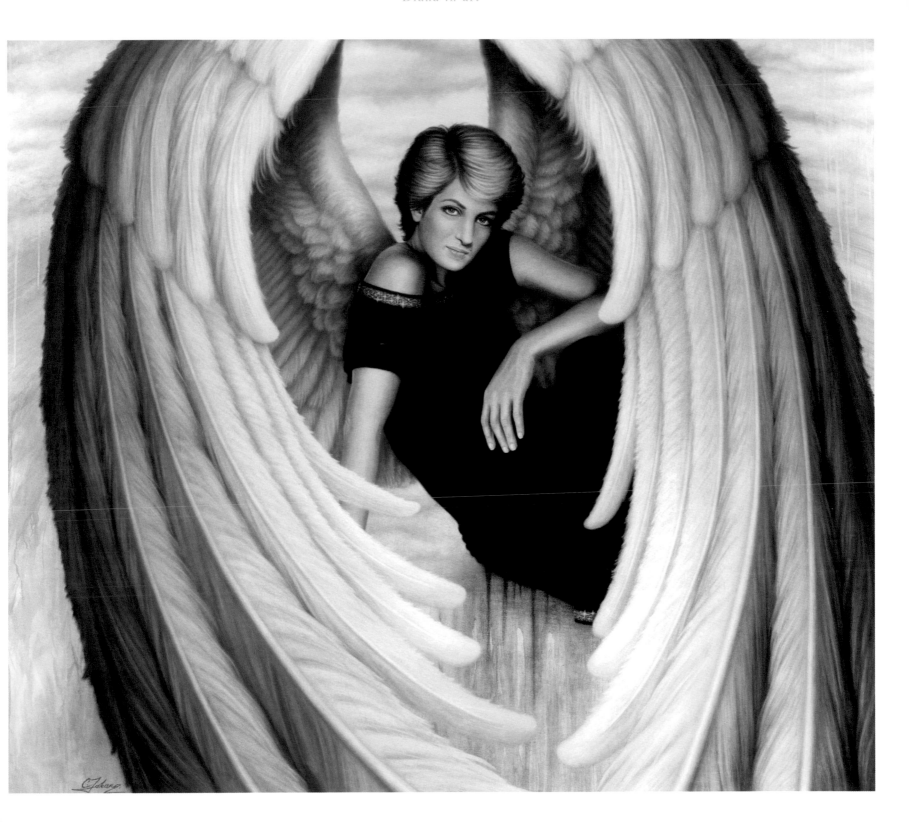

The people said it with flowers. So many threw bouquets at Diana's hearse that the driver had to stop to clear the windscreen.

Daily Mail

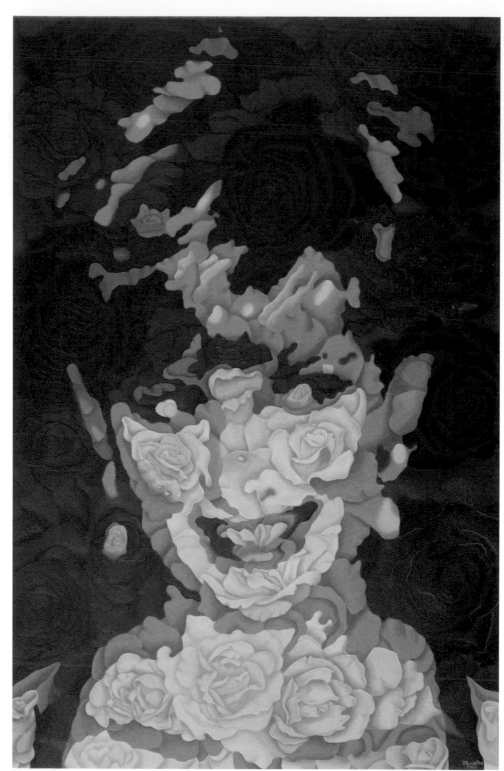

WERNER HORVATH

Roses for Diana

oil and acrylic on canvas

90 x 60 cm

Many have written that Diana died at her most happy, but she also died at her most beautiful. Now, she will be forever thus, trapped on film at the height of her power. It is a chilling thought that had she not been quite so appealing to the camera then she might be alive today.

Mimi Spencer
Journalist

JOSE ANTONIO MORGADO LEONARDO

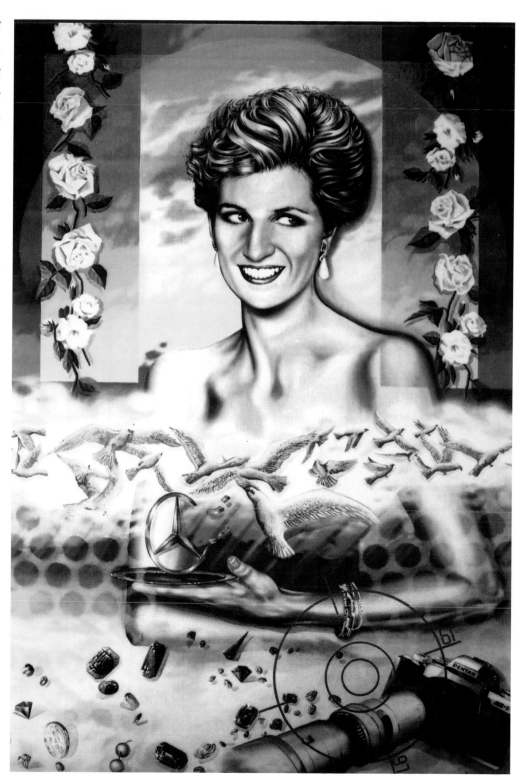

Princess Diana, 1997
acrylic on canvas
160 x 114 cm

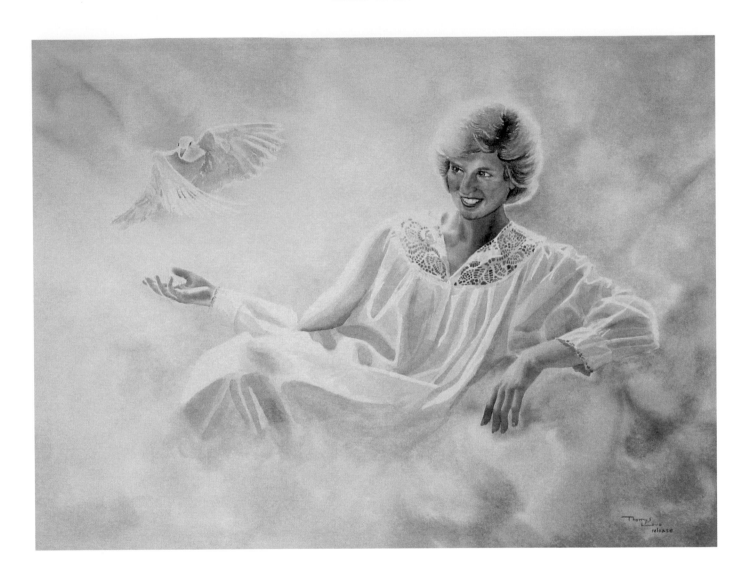

I thank God for the gift of Diana and for all the caring and giving. I give her back to Him, with my love, pride and admiration, to rest in peace.

Frances Shand Kydd

Mother

THOMAS LOVE

Release

watercolour on Arches paper

53 x 71 cm

She was buried on an island in a lake at the heart of the estate, which she loved in childhood, and where her sons can now visit her in privacy whenever they want. Who lies there now? A beautiful young mother, cruelly cut off in her prime? An incarnate idea whose time had come, inspiring Britain to cast off its post-imperial shackles and look to its European future? A martyr to the media age? Or a saint in the making, who by her own example has turned us all into better people?

Anthony Holden
Author

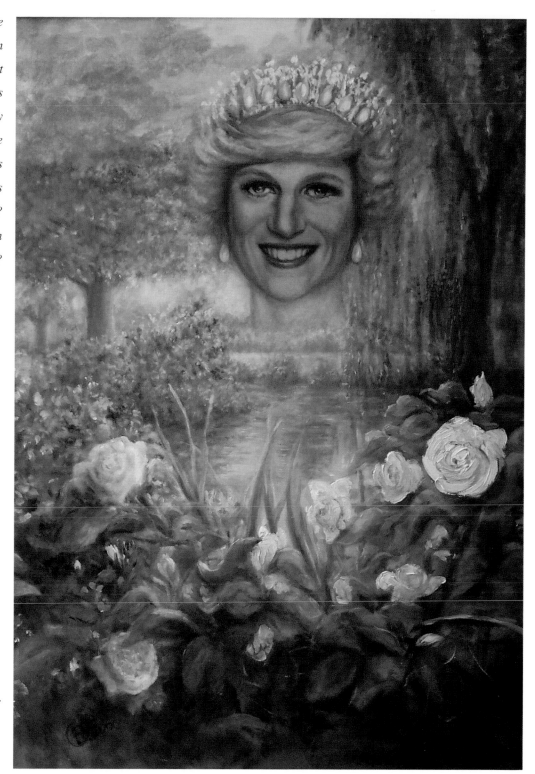

BRENDA NORTHEAST

Diana, Rest in Peace

oil on canvas

77 x 62 cm

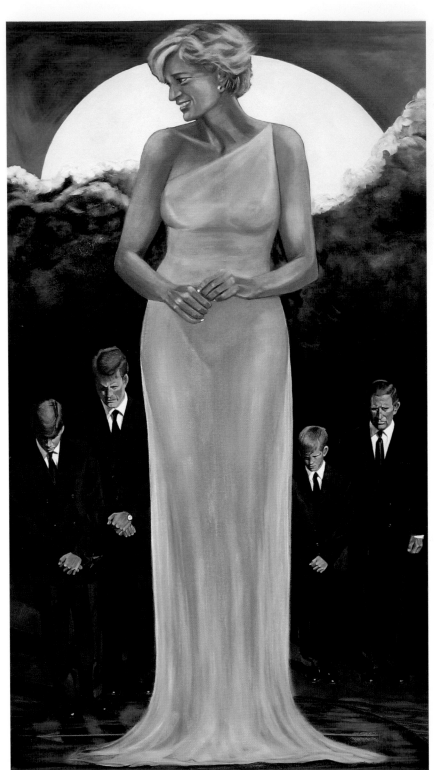

The worst experience of my life was walking behind my sister's body to Westminster Abbey. Worrying about the boys and thinking, you know, this is all so horrendous and so public, and having to keep your eyes straight ahead and not look either side.

She was the unique, the complex, the extraordinary and irreplaceable Diana, whose beauty, both internal and external, will never be extinguished from our minds.

Earl Charles Spencer

LENORE MCGOVERN

You Must Remember
acrylic on canvas
117 x 193 cm

DR T. F. CHEN

Sunny Mourning *(opposite)*
acrylic on canvas
122 x 167.5 cm

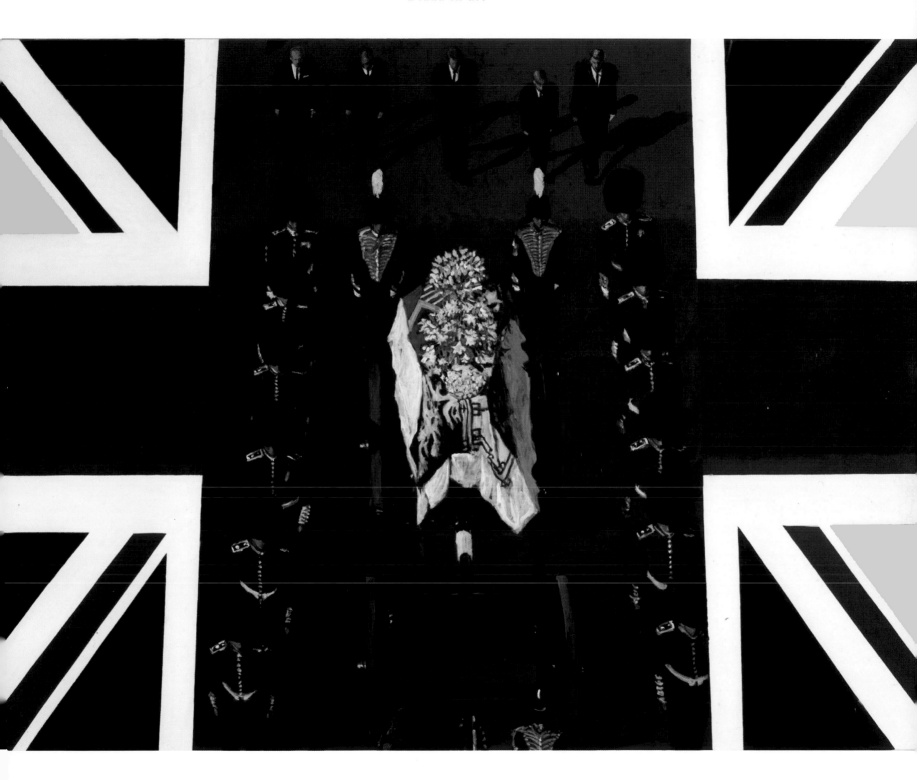

INDEX OF ARTISTS